couplesdiscourse

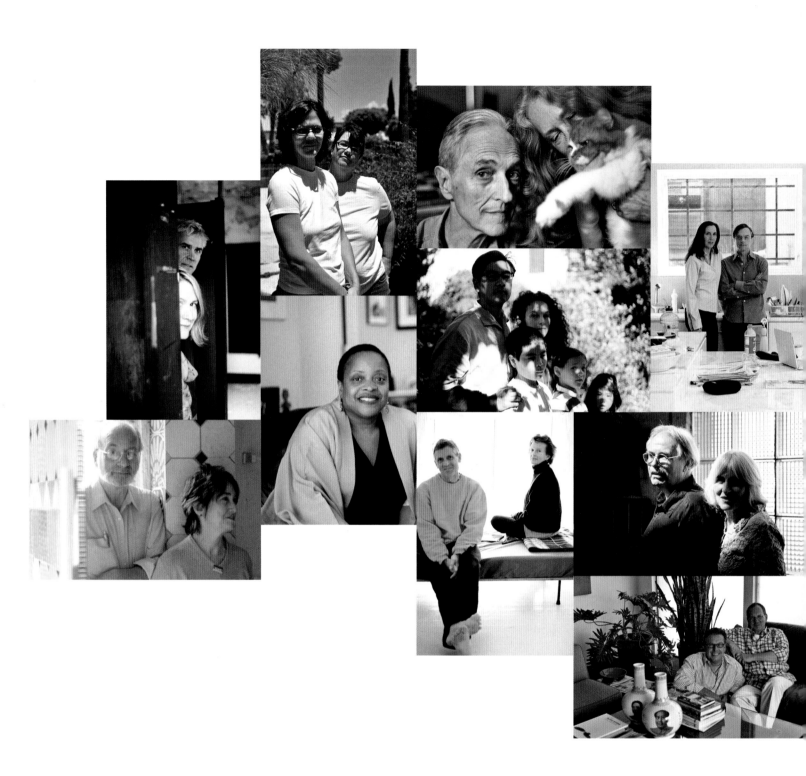

Palmer Museum of Art | The Pennsylvania State University | *distributed by* The Pennsylvania State University Press

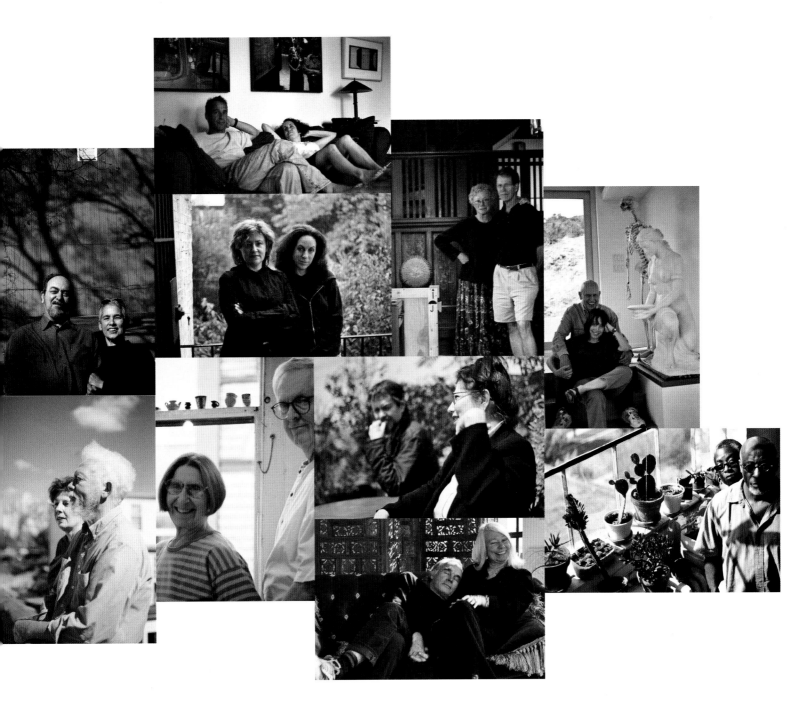

couplesdiscourse

Micaela Amateau Amato and Joyce Henri Robinson, curators

with an essay by Sarah K. Rich *and contributions by* Sarah Holloran, Barbara Kutis, *and* Christine Swisher

Photographs by Jenny Rogers

Published in conjunction with the exhibition
Couples Discourse, held at the Palmer Museum of Art,
October 10 – December 22, 2006.

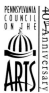 The Palmer Museum of Art receives state arts
funding support through a grant from the
Pennsylvania Council on the Arts, a state
agency funded by the Commonwealth of
Pennsylvania and the National Endowment
for the Arts, a federal agency.

ISBN: 0-911209-65-4

U.Ed. ARC: 06–205
Library of Congress Control Number: 2006904586

Designed by Jennifer Norton
Edited by Amy Milgrub Marshall and Cherene Holland
Printed in China

*Penn State is committed to affirmative action, equal opportu-
nity, and the diversity of its workforce.*

PHOTO CREDITS: Simon Watson, p. 7; Abe Frajndlich, p. 10;
Jerry Mathiason, p. 57; Tom Powel, p. 62; Adam Husted,
p. 63; John Groo, p. 71; Christopher Burke Studio, p. 75;
D. James Dee, p. 79; Josh Stone, p. 87; Bill Orcutt, p. 91;
Kerry Ryan McFate, p. 93; Richard Ackley, Penn State
Campus Photography, p. 107; Douglas Parker Studio, p. 111;
K. Doofy, p. 113; Jim Nutt, p. 115; Ron Gordon, pp. 117, 119;
Mary Lucier, p. 121.

COVER ART: Carroll Dunham, *Female Portrait (Second
Generation, B)*, detail, 2003, painted aluminum and wood,
65 x 78 x 25 inches. Photo courtesy Gladstone Gallery, New
York. Copyright Carroll Dunham 2003

Couples Discourse is

dedicated to Betty and

George Woodman,

artist-couple extraordinaire,

and to the indomitable

Nancy Spero and Leon Golub

(1922–2004).

SEVERAL YEARS AGO I began thinking about and mapping out a couples exhibition, a scaled-down version of the present show, which I originally envisioned installing in the Zoller Gallery of Penn State's School of Visual Arts. Since that time the exhibition has grown in scope and has changed venues, and the single curator has evolved into a curatorial couple. *Couples Discourse* was and is intended to be a love letter to the couples who served as great role models for me as a young artist, graduate student, and faculty wife. My first marriage to an art historian taught me that mates must nourish and challenge each other and be there to share the discoveries and successes, as well as the disappointments and anguish, that inevitably accompany the emotionally peripatetic life of the artist. My second marriage—this time to a practicing artist—has confirmed that partners can and must grow symbiotically together into old age as producing artists. Continuing to work in the studio at all after a lifetime of domestic, personal, and professional demands, let alone at "maximum peak," remains the greatest challenge.

All of the artist-couples in this exhibition have crafted a life together and engage in an ongoing symbiotic discourse—perhaps none more so than George and Betty Woodman, whom I met in Boulder, Colorado, almost forty years ago. The intensity and steadfastness of their devotion to each other and their art, and their ease in making life extraordinary on many levels, served then and serve now as a source of strength for me. I thank them for that with the deepest gratitude.

Betty's and George's work articulates an aesthetic of sensual pleasure and a lifestyle of disciplined rigor, ritual, and ceremony. Together they are the prototype for Betty's composite double-sided vessels—the recto/verso of which Sarah Rich writes in this catalogue—portraits of an "ideal marriage," to quote Arthur Danto's recent description of Betty's matched ceramic pairs. George's early, intricately patterned paintings employ a vast matrix of interlocking tessellations, a mosaic of interdependent,

interconnected forms, equally emblematic of the couple's fifty-plus years together.

George and Betty have bolstered each other through devastating loss, particularly the death of their beloved, creative daughter, Francesca Woodman, a brilliant photographer whom I had the pleasure to know. (Her brother, video artist Charlie Woodman, completes the portrait of this creative family). Francesca's loss can be immediately sensed in George's haunting photomontages, visual laments in which apparitions of the souls of the departed appear to commune with the accoutrements of the living. It can also be perceived in George's geometric paintings of the 1980s, in which, uncharacteristically, female bodies emerge from densely patterned, interlocking spaces.

Although both acknowledge that their lives were forever changed by Francesca's death, Betty has recently stated that she believes the impact of that loss is more apparent in the work of the grieving father than in her own oeuvre. Yet, Betty's habit of shifting what is expected, and her strategy of silhouetted, cut-out reversals, or "twinning," echoes Francesca's photographic self-portraits in which her own image is juxtaposed and mirrored. "Twinning" exposes the whole, composed of its fragmented parts, a representation of self and the non-self, or void, simultaneously. Similarly, Betty's three-dimensional vessels, uncannily like Francesca's self-portraits, disappear and reemerge from the two-dimensional, camouflaged pattern of her ceramic wall paintings, one of which is included in this exhibition.

Like all of the artist-couples in *Couples Discourse*, Betty and George face life's challenges hand in hand, buoyed by their intimate partnership and poignantly channeling their personal experiences into effulgent creations redolent with meaning. This exhibition catalogue is dedicated to them and to Nancy Spero and her late husband, Leon Golub. Anyone who has had the privilege of knowing Nancy and Leon, observing their belief in one another, or hearing them talk about their work,

family, and life, has witnessed an intensely moving love story and watched provocative history unfold.

And, finally, I add my thanks to my curatorial half, Joyce Robinson, for her support and for her patience with my unbridled passion for this project. Together we acknowledge the courage, spirit, and the luminosity of all the artist-couples in the exhibition, whose work inspires us all.

Micaela Amateau Amato

‿

THE SAYING HAS IT that opposites attract, but societal practice—particularly among artists—and this exhibition seem to suggest otherwise. *Couples Discourse* brings together recent work by twenty-one artist-couples from New York, California, and the Midwest. Dual-career rather than collaborative twosomes, these contemporary couples have enjoyed long and productive careers in the company of life partners whose passions and interests have been and remain centered on the creation of art.

The exhibition takes its title from Roland Barthes' *A Lover's Discourse*, a book in which the philosopher attempts to theorize the language used by lovers to describe each other. As Sarah Rich argues in her essay, it is arguably a text about loneliness, suggesting that even romantic language confesses the distance that always exists between people—if we could achieve perfect unity with others, language would not be necessary. This exhibition and its accompanying catalogue are about how "couples" discourse (N.B., we are using discourse as a verb) and the ways in which their work does—and does not—engage with the intimate dialogue and personal give-and-take that are so critical in any relationship.

Micaela Amato and I came to this project literally from opposite sides of the same university street—the art department and the museum of art—and I am eternally grateful to her for proposing the exhibition and for her dedicated work as a partner in

this curatorial team. Micaela and I both thank Sarah Rich for her insightful essay and for being conversant with everything from Barthes to Bravo and back. We are also indebted to our photographer, Jenny Rogers, who went well beyond the call of duty, visiting twenty of our couples in their homes and studios across the country and capturing her remarkable images with astounding good cheer and enviable organizational skills. Special thanks, too, to our gifted catalogue designer, Jennifer Norton, who responded gracefully to our many requests while maintaining the integrity of her own vision.

The task of orchestrating loans, securing photographs, and verifying pertinent information was made much easier by the gracious assistance of the following individuals: Lauren Rice and Dorian Bergen, ACA Galleries, New York; Ted Bonin, Alexander and Bonin, New York; Phil Alexandre, Alexandre Gallery, New York; Heidi Lange, DC Moore Gallery, New York; Josh Kline, Electronic Arts Intermix, New York; Mark Hughes and Stephanie Joson, Galerie Lelong, New York; Miciah Hussey, Bridget Donahue, and Adam Ottavi-Schiesl, Gladstone Gallery, New York; Josie Browne, Chris Davison, and Brandon Noble, Max Protetch Gallery, New York; Katherine Chan, Nolan/Eckman Gallery, New York; Douglas Baxter, Charlie Manzo, and David Goerk, Pace Wildenstein, New York; Sarah H. Paulson, Martina Batan, Marco Nocella, Emily Poole, and Marina Berger, Ronald Feldman Fine Arts, New York; Molly Epstein and Karen Polack, Sperone Westwater, New York; Andrew Arnot and Rebecca Moed, Tibor de Nagy Gallery, New York; Wendy Brandow and Sarah Nichols, Margo Leavin Gallery, Los Angeles; Julie Hough, Kristina Kite, and Dawson Weber, Regen Projects, Los Angeles; Rebecca Kerlin, Gallery Joe, Philadelphia; Jannette Rho, gescheidle, Chicago; Jean Albano Broday, Jean Albano Gallery, Chicago; Howard Yezerski and Alexis Dunfee, Howard Yezerski Gallery, Boston; Caroline Taggart, OH+T Gallery, Boston; Tina Hejtmanek, Plane Image; Katarina Jerinic, Woodman Studio; and Patrick Terenchin of Studio 58 at Ruby Lane.

Because the exhibition was many years in the planning, numerous graduate assistants contributed time and energy to the project, among them Betsy Johnson, Elizabeth Hoorneman, Janalee Emmer, and Courtney Jordan. Sarah Holloran, Barbara Kutis, and Christine Swisher assisted greatly with research on the artists and wrote several of the catalogue entries. Their unflagging assistance was much appreciated and critical to the completion of the catalogue. Gloria Kury, formerly of the Penn State University Press, provided much encouragement early on. Cherene Holland, Amy Milgrub Marshall, Elizabeth Warner, and Barbara Weaver were most capable editors and proofreaders, and we thank them for their efficiency and interest.

We thank Barbara and Ira Sahlman and Ian Rosenberg, who generously parted with works from their private collections for the duration of the exhibition.

To Jan Keene Muhlert, director, Palmer Museum of Art, and to the Palmer staff, Micaela and I offer sincere thanks for enabling us to present *Couples Discourse*. We also gratefully acknowledge the support of the Pennsylvania Council on the Arts and George Dewey and Mary J. Krumrine Endowment in the production of this catalogue.

And, last, but surely not least, we thank all of the artist-couples included in the exhibition. Their patience, good humor, and willingness to communicate—along with their enviable creativity and talent—were critical to the success of *Couples Discourse*.

Joyce Henri Robinson

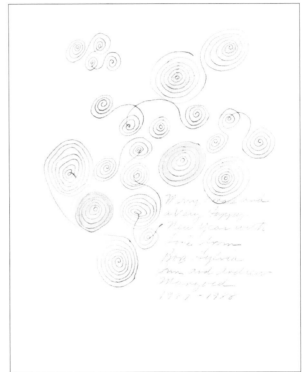

Robert Mangold and Sylvia Plimack Mangold, *Holiday Card*,
1987, colored pencil on paper, double-sided, 6 1/2 x 5 1/4 inch-
es. Photo courtesy the artists and Patrick Terenchin, Studio 58,
Ruby Lane

Recto/Verso

SARAH K. RICH

RECTO: A green oval shape balances on its narrow end, as the chin of a face might rest upon a table. As perched, the central oval threatens to tilt off balance, suggesting an instability that is also prompted by the four oblique, tangential lines that frame it. The central form and the surrounding sections are a *bit* eccentric (this is an oval, not a circle; a green rhombus, not a square), but in pretty subdued ways. Some of these formal eccentricities beckon empirical confirmation. A ruler might come in handy. And it's not entirely clear which deviations from perfect regularity are intended and which are accidental— like that tilting effect, in which the four orange triangles make it look as if the whole composition might be at an oblique angle in respect to the sides of the paper.

VERSO: Rococo curlicues swim in pastel tides and eddies. Colors are not framed by line so much as they subtly warm up districts of the spirals— centers and circumferences—like blush on a cheek. Lines wander across the page and dawdle in off-center places, twisting around themselves and one another. Exteriors warp and wrap into interiors. Some of the delicate coils balance on lines like acrobats on a tightrope; others bounce like sections of a wire spring.

The two images might be considered opposites: One seems deliberate, the other almost a doodle. One required a straight edge and compass, the other was clearly freehand. One sits directly in the center of the page, the other roams upward and to the side, freely, without obeying strict marginal constraints. One composition works according to a somber economy of forms, the other frolics. And yet these images clearly came from the same box of colored pencils—the same blues, greens, yellows, and orange are to be found in both, though with different saturation and location. The two drawings also appear on the same sheet of paper, though on different sides, and were probably made at about the same time, as is suggested by the inscription:

Merry Xmas and a Very Happy New Year with Love from Bob, Sylvia, Jim and Andrew Mangold, 1987–1988

The card is indisputably the product of a "couple." Sylvia and Bob Mangold produced these back-to-back compositions as part of that familiar yearly potlatch wherein cards are exchanged in rituals of social confirmation. Sending their card through the heavy traffic of holiday mail to friends and family, the Mangolds announced and affirmed their status as a cohesive, externally sanctioned unit. Their private connections (erotic and other attachments less given to verbal articulation) are here trumped by their joint public persona as wife and husband, father and mother, artist-team-of-two.

Now, I like the Mangolds' card, not because it is a calculated collaboration between artists, or even because it is a well-known or art-historically important one (it's just a holiday card, for heaven's sake), but because its arrangement stages the couple themselves in a recto/verso relationship. Allowing dissonances and disconnections to emerge between their respective pictures, this artist-couple makes little effort to provide a unified front for their card. Rather, their artistic styles remain intact even when separated by the thin membrane of a piece of paper. This is a condition easily extrapolated to the larger oeuvres of the Mangolds as well, of course. These two artists are, after all, one of those couples that maintain artistic independence in spite of their long-lasting, famously close relationship. Such differences might frustrate those who prefer to think of couples as organically whole, hermetically sealed units—couples locked in similar modes such that the two members seem more like twins than partners. Not so the Mangolds. They seem to relish the differences between their respective styles and even enjoy the fact that each can still be surprised by the other's work. As Robert suggested in the statement he and Sylvia submitted for this exhibition:

One would think that after such a long, mutual involvement everything would blur and merge, but despite all manner of shared experience and influence, Sylvia's work is uniquely her own and a mystery to me, as I think mine must be for her.

Neither seems indebted to the other, and the two remain a mystery to each other.

And yet, like the two drawings on the card, the work of the artists might become more provocative when placed in juxtaposition. As one weighs the morphological differences and similarities between the two images, in other words, the viewer might marvel that two such disparate artistic temperaments can coexist. Indeed, the card tempts us to guess at (even envy) the artists' strategies of tolerance and mutual appreciation—their respect for the *mystery* of the other—that allow such differences to thrive in one long-term relationship.

These artists are, like so many artist-couples in *Couples Discourse*, in a recto/verso situation. Like two designs on opposite sides of a piece of paper, the artists gathered together by the exhibition's curators often draw from the same set of conditions and resources, as well as emerge at about the same time and place, and yet they can operate independently. So these artists are not necessarily collaborative duos, in which the two artists work together on a shared project, though there are some artists in the group who do that. Neither do most of the artists in this exhibition always typically produce works that address the experience of being in a couple, though some artists do that, too. Thus, the viewer will have an opportunity to examine more subtle, often unintended similarities between artists who work closely side by side, and who cope with the practicalities of being artists in a couple. This show is about the differences as well as the commonalities, the public articulations as well as the intimacies—in other words, the social *negotiations* that are required in any relationship.

For some artist-couples, the conceptual links between their respective projects are plentiful, even if the formal similarities may be scant. Suzanne Anker and Frank Gillette, for example, share a preoccupation (they urbanely call it a *folie à deux*) with "the specimen" and other categories operative within the visual culture of natural sciences. Some couples might choose to locate their most powerful artistic connections in unexpected areas: Roy

Dowell and Lari Pittman share a passion for gardening, and their comments regarding the intricacies of domestic landscape might surprise those who were expecting the artists to discuss their respective critiques of modernist collage. Other artists have already become well known for their shared collections. Like Dowell and Pittman, Jim Nutt and Gladys Nilsson draw on a rich vocabulary of funky forms in their work, provided, in part, by their substantial collection of folk and "outsider" art.[1]

Many (if not all) of these couples are legendary for the longevity and intimacy of their connection. Betty and George Woodman, for example, famously encourage each other. Although they work in very different media (George in photography, Betty in ceramics), one member of the couple hardly writes an article or gives an interview without referencing the support of the other. In personal statements, Betty often includes detailed explanations of the practical ways—from sharing grants to negotiating child-care challenges in foreign countries—in which she and her husband have helped each other to flourish as artists and as a family.[2] George, on the other hand, has woven his wife into some very beautiful critical essays about aesthetic response.[3]

Because many of the artists in this show have been couples for a long time, they have developed a keen understanding of the ways in which their joint artistic identity is publicly perceived. The resulting relationship between artists and the art-viewing public can be a negotiation involving some assumptions, misperceptions, and reversals of opinion. In one interview, another legendary artist-couple, Nancy Spero and Leon Golub, struggled with this external view of their connection. When an interviewer pressed Leon to explain the ways in which his work related to that of his wife, he responded:

> These are the paradoxes in who we are as artists and what we stand for. I am deeply implicated in Nancy's work, okay. And Nancy is deeply implicated in much of mine. We challenge the other's conceptualizations as well as critiquing process. What I'm saying is quixotic because

among the nobility (the public celebration of aristocratic marriages being a long-standing tradition in France), it is the crossing of class lines within the "royalty" of the popular media that most fascinates: Miss Europe marries her childhood sweetheart of humble origins, Marlon Brando marries small-town French girl. These are the stories of romance and intrigue across opposite ends of social spectrums the likes of which might thrill readers of Samuel Richardson and *People* magazine alike. Of course, there has been a shift in what "the social" is to signify here. "Class," freshly disarmed as a political category because it has been severed from notions of economic determinism, appears instead as the anodyne glow of mass popularity accruing around the media nobility.

While Barthes' parable of the *lover* comments on the general condition of language as an ahistorical category, his argument regarding the spectacularization of *couples* focuses on a historical trend—a trend concerning the category of the "famous couple," which has arguably reached its crescendo today. Indeed, an exhibition like this one is so appropriate at this moment precisely because of current and ever-quickening curiosity about the public function and performance of Coupledom. The very notion of the couple has reached such a level of cultural saturation that its resonance within the arena of artistic contemplation is due.[9]

With the advent of reality television, an entire subgenre of programs has been devoted to crafting media performances of Coupledom. Such shows, many of which are contests for prize money, increasingly suggest that the main reasons for becoming a member of a couple are strategic and financial. While one could (quite correctly) argue that marriages have historically served instrumental purposes exceeding notions of romantic attachment, recent television spectacles have staged the colonization of relationships by capitalism with breathtaking frankness. Programs such as *Paradise Hotel* (where contestants need to become part of a couple in order to win money), *Joe Millionaire* (in which a veritable harem of women compete against

one another for the "love" of a single man—who in fact is *not* a millionaire—in order to win cash), *The Bachelor*, *The Bachelorette*, and *Who Wants to Marry a Multi-Millionaire* more often than not argue that coupling is a device by which one obtains wealth or fame. Meanwhile, programs like *Bridezillas* (brides who become shrewish during preparations for their weddings) and *A Wedding Story* chronicle the preparations for marriage ceremonies proper, with special attention given to the exorbitant fees paid for ostentatious centerpieces and the like (debt usually being the first of any married couple's joint possessions).[10]

Although programs like Bravo's *Gay Weddings* have offered some relief to those tired of walking the straight and tedious, most of these programs are predictably heterocentric and disavow same-sex couples. In the process, as Judith Halberstam has recently argued, the peculiarities and cynical materialism of such programs end up painting a rather disturbing picture of heterosexuality.[11] The alacrity and capriciousness by which couples are conjoined suggest that heterosexual coupling is an arbitrary thing rather than a natural process. And other spectacles of courtship, such as *Queer Eye for the Straight Guy* (in which a posse of style-savvy gay gentlemen coach a straight man into impressing his girlfriend or wife), gleefully reverse the common prioritization of hetero- over homosexuality, as the straight character defers to gay expertise.

In the meantime, celebrity itself seems ever more contingent on one's couple status. Television programs like *Newlyweds* (featuring the now-defunct couple made up of bubblegum pop star Jessica Simpson and that other guy) offer a pungent example of the ways in which domestic banalities are not, in fact, brightened by fame. With the advent of such simulacral Coupledom comes a new lexicon developed by the popular media as well: Hence the great deliberations with which pundits have ascertained the correct syllable by which the names of celebrity couples may be conjoined (for example, "Bennifer" for Ben Affleck and Jennifer Lopez). The resulting proper name shorthand

two couples are at work, of course, as the Jerry/George couple ponders George's membership in (what might be) another couple. That the burden of ascertaining his couple status is too difficult a project for George to accomplish alone is a joke at the expense of that character's celebrated intellectual deficiency, but it also implicitly acknowledges the ways in which any couple is always already triangulated by a third term (*that* is the obligatory "other couple"—the mediation by a friend, a family, or society at large) by whom witnessing and confirmation must take place. So Jerry and George test the identity of the couple according to rituals of interaction in time (Daily calls? Weekly dates?) and conventions of assumed knowledge (Are plans explicit or tacit?). And, as is usual for any epistemological concern under capitalism, the definitive litmus test involves consumer products. Commodities mark George's home as the turf for a new, additional body. They are also signs of sacrifice, evidencing that George has made such a commitment to the relationship that he is willing to withstand the detrimental effects of moisturizer and Tampax on his masculinity.

One could argue that it is precisely this triangulation of a relationship through a social other that establishes the difference between *members of a couple* and *lovers*—a distinction that has fascinated many, and that was clarified in two different publications by French philosopher Roland Barthes on the subject of relationships. In his poignant book *A Lover's Discourse*, Barthes attempted to catalogue a vocabulary of longing between people romantically involved. Barthes' text is arranged like a dictionary, though it is a sort of anti-dictionary—an alphabetical list of terms (*absence, adorable, affirmation...*) with no pretensions to rigor or mastery. Incomplete and unobjective, it is a list that is indisputably partial. The entries are wistful and full of pining. Under the definition of "Waiting," for example, Barthes writes, "Tumult of anxiety provoked by waiting for the loved being, subject to trivial delays (rendezvous, letters, telephone calls, returns)," then Barthes' voice lapses into the first person, "I

am waiting for an arrival, a return, a promised sign. This can be futile, or immensely pathetic."[7] In a popular context, romantic language is often trivialized as the expression of an authentic connection, but for Barthes, the lover is in a state of depletion, not plenitude. The lover occupies the precarious position of desiring rather than having. The lover is not in an embrace but, rather, anticipates or remembers embraces from a distance. The lover waits, paces, worries, and recapitulates. In lonely isolation, the lover persists without the comfort of being in a couple.

For Barthes, the lover is the personification of language itself. All language is a sort of "lover's discourse," for language is always about separation from the world. Language, which operates in the gap between signifier and signified, between word and world, would not be necessary if we lived in an immediate connection to all things. It is only because absence is the fundamental condition of human beings in respect to things that language is indispensable. We are all, therefore, lovers pining for a world that we have lost with the invention and intervention of language.

By contrast, Barthes' interest in *couples*, rather than in *lovers*, appeared in a shorter, chattier piece entitled "Conjugations." While *A Lover's Discourse* is about language and loneliness, this essay is arguably about *crowds*—the mass appeal of couples.[8] For Barthes, the couple is always already a public thing—a phenomenon aptly demonstrated by his short, pithy contemplation of celebrity Coupledom. Indeed, "Conjugations" might have been written today, so handily does it dispatch the illustrated glossies through which famous marriages and other unions are celebrated. "What a lot of marrying goes on in our illustrated papers," Barthes begins, wryly, as if to say that in a society of public spectacle, quantity by far outweighs quality in such things as sacred unions.

As is typical of Barthes' early writings, "Conjugations" contemplates the shifting boundaries of class identity within the popular media. So, while Barthes might give a brief nod to marriage

in some ways, is the paradigmatic audience for her husband. She knows him best, her tone of intimacy suggests. At the same time, however, David remains a figure of mystery—a sneaky guy, a wily son of a bitch—who defies even her complete description. Yet, Eleanor embraces the reader (an external audience) as a privileged figure. We are implicated in her text, as she tells us "secrets" about the relationship. Telling a secret in a published text like this is like screaming it through a bullhorn, of course, but that is part of the fun Eleanor pokes at the public/private dichotomy of the couple. Supposedly we, her insider audience, are learning something the uninitiated outsider audience misses. Eleanor watches David, David watches Eleanor, the reader of the statement (privy to Eleanor's "secret") watches the couple, audiences watch the artists at work— circles of witnessing extend outward centrifugally and overlap in unexpected ways. Audiences watch audiences, and the couple watches itself. And the couple, here, is not so much a stable thing as it is an *event* of reading and misreading. The couple is a nexus of observations.

A DEFINITION OF TERMS

It might be a truism to say that the very notion of the "couple" is undergoing significant transformation at the moment. Challenges to the heterosexual bias of marriage laws—and subsequent relapses into homophobia with "defense of marriage" amendments to state constitutions—have forced most Americans to confront on some level their presumptions about the ways in which two people might be publicly confirmed as a couple. At the same time, increasing numbers of people in the United States, both gay and straight, choose to enjoy unions and family structures beyond conventional forms such as marriage.[6]

Indeed, for all its connotations of the mundane and the routine, the "couple" is an elusive entity, a mysterious thing. Its exact parameters can be notoriously difficult to map. Less paperwork is involved than for something like *marriage*. Coupledom does not necessarily require such bureaucratic sanction-

ing, nor does it necessarily enjoy the rights and privileges that marriage ensures. And while the question of whether or not one is married can be answered through legal jurisprudence, the question of whether or not someone is part of a couple is more the stuff of opinion, smaller commitments, external affirmations, and joint possessions. If you share a child, are you a couple? Not necessarily. If you share real estate, are you a couple? If you have sex—with each other—on a regular basis?

But, of course, the coefficient of one's Coupledom cannot be easily plotted along a graph showing a correlation between things like coital frequency and relationship status. Rather, it is a problem of epistemology. Recognizing a couple as such is a function of knowledge. It all emerges within definitions that are discursively established and constantly under negotiation within communities that by far exceed the two people primarily involved.

> Jerry: What's your phone call frequency? Are you on a daily?
> George: No. Semi-daily. Four or five times a week.
> Jerry: What about Saturday nights? Do you have to ask her out, or is a date implied?
> George: Implied.
> Jerry: She got anything in your medicine cabinet?
> George: There might be some moisturizer.
> Jerry: Ah hah. Let me ask you this. Is there any Tampax in your house?
> George: Yeah.
> Jerry: Well, I'll tell you what you've got here.
> George: What?
> Jerry: You got yourself a girlfriend.
> George: Ah, no, no. Are you sure? A girlfriend?

It is unquestionably a violation of proper academic decorum to reference *Seinfeld* in an essay that also discusses the Mangolds, but I insist on the quotation. No contemporary authority better dramatizes the ambiguity of social boundaries and the epistemological crises of relationships. In this tiny dialogue,

anyone viewing her work would know I have nothing to do with it. Anyone looking at my paintings couldn't conceive that Nancy could have input. Our work is highly differentiated, it represents different worldviews. Male personifications, seemingly exaggerated versions of the male . . . and hers, perhaps extreme versions of the female persona.[4]

There is an honesty in Golub's statement that is refreshing, even if the "paradoxes" he describes are a bit frustrating. Golub triangulates his connection to Spero through a hypothetical witness who seems at once authoritative and fallible. "Anyone viewing" their work would "know" that neither artist has anything to do with the other's work, though it is not entirely clear if Golub thought such a witness would get it right or wrong. Although he acknowledged his and Spero's famously shared commitment to social critique and progressive politics, Golub also embraced the difficulty of any attempt—for himself or for the hypothetical viewer—to establish a common denominator between their respective efforts. Within the boundaries of the couple, the two artists are in agreement, though Golub says that they also critique each other's work. In the eyes of an external viewing public, the artists might "stand for," signify, the same thing, and yet anyone looking at their paintings, Golub imagines, would see only differences between them. The couple seems to persist in the spaces around these opinions—in the compromises and negotiations that operate both privately and publicly.

It might be that artists are particularly sensitive to external perceptions of their relationships in part because artists are frequently courting, anticipating, thwarting, or struggling to ignore audience reactions to their work—external judgments about their romantic life seem just one step away. It is therefore remarkable that many artists in *Couples Discourse*, like Golub, frequently recruit an imagined viewer or reader as a means of defining (or avoiding definition of) members of the couple. For many, this imagined figure exemplifies the ways

in which one might, in fact, *misunderstand* their relationship. Max Kozloff recently engaged in this sort of fantasy as a means of illustrating the differences between his work and that of his wife, Joyce Kozloff, both of whom take an interest in the visual culture of travel:

> If one were to see us on a trip—nominally a vacation, but in fact a "field" trip—one would be deceived as to who is working and who is playing. I'd maybe look like the one who had business afoot with a camera, and Joyce, apparently the vacationer who's just taking in things. In fact, her response to what is happening is probably more intense and strenuous than mine. I'm more capricious, diffused.[5]

In their statement for this exhibition, Eleanor and David Antin carefully manipulate this trope of the hypothetical reader/listener/viewer as a way of interrogating the means by which artist-couples are crafted. Writing their statement as a dialogue rather than as a consensus document, the two artists speak around each other for the benefit of the reader. At one moment, in a typically irreverent tone, Eleanor describes her husband:

> . . . David is sneaky, too; he doesn't give himself away, he's the last of the Mohicans, that guy. He's a trapper following the tracks; his thoughts are lying before him, silently coming up on them to get where they're leading, stopping under a tree to relax, take a drink, remember a story, a joke, but never forgetting the journey, always coming closer, tighter, until he's out of the forest, which opens up to reveal itself And I'll tell you a secret . . . I've seen him retrace his steps, go back and start again, and he's such a wily son of a bitch, nobody realizes it, because they're enjoying the trip so much, they're lulled by his courage . . .

Here is a contrapuntal set of connections through which Eleanor is weaving different audiences. She,

ostensibly accommodates the speed and frequency with which such celebrity unions are discussed ("Bennifer" requires less exertion of the fingers than "Ben and Jennifer"), even as it presumes the inseparability of the two figures who have morphed into one entity. This is a cruel nomenclature, of course, as the media, sharpening their knives to sever the word again, eagerly await the dissolution of the very couple whose union they had so recently heralded.

Few couples in the art world have come close to achieving the Nielsen ratings enjoyed by those who usually walk red carpets hand in hand, though Matthew Barney and Bjork have, for better or for worse, crossed over into that notoriety such that paparazzi might hide and pounce for shots of their offspring. But if the art world's duos do not enjoy the same level of celebrity or popular fascination, they do, on occasion, receive a good amount of attention as a couple. *New York Magazine*'s recent set of stories about interior design for spaces that function as domestic spaces and studios, for example, featured a long spread about Brice and Helen Marden's place on the West Side—a sun-drenched sanctuary that has become a prestigious pilgrimage destination for critics. (On several different occasions, art-world hipsters have bragged to me about having visited "Brice and Helen's.")

In Simon Watson's photographs, gray concrete floors, whitewashed walls, and metal windowpanes frame the two artists as the representative couple of modernism.[12] This shared space is cool and uncluttered—decidedly unsentimental. She is above, he below. She is cast as an introvert (her back, turned to the viewer, is crisscrossed with window latticework). He is pictured as more accessible, facing the viewer, unobstructed by windowpanes, and looking upward, though not at Helen. He is no Romeo at the balcony. Rather, he is a cohabitant of a dispassionate space, a fellow citizen in a society of two. This sort of domestic environment contradicts common expectations regarding gender and spatial arrangements. Refusing the domestication that would befall Lee Krasner (particularly in photographs of her

Studio of Helen and Brice Marden, photograph by Simon Watson, *New York Magazine*, April 9, 2001

with her husband, Jackson Pollock, in the fifties), Helen is neither bubbly hostess presenting the loft to us, nor is she the diligent housekeeper who keeps it tidy. The space is also free of the materialistic cues that so often adorn images of domesticity in contemporary visual culture. Rather, because the couple is positioned within an architectural grid, this environment stages the two figures as artists who allow each other the space to test their modernist inheritance in their own individual ways.

One might say that, though it appears on glossy pages along with other images of celebrity couples, the Mardens' studio space siphons off some of the sentimentality and materialism to which consumerist spectacle of the couples typically subjects us. Indeed, many of the couples in this exhibition drive a wedge into typical stories of wedded bliss or domestic contentment as they seek slightly more creative forms of mutual affirmation. When, for example, Eleanor Antin was recently asked about

the humor in her work, she came up with a surprising example—her wedding day:

> [The] Justice of the Peace . . . came in and said suddenly, "Hello, Hello, Do you Eleanor take this man!" I took one look at him and what he was saying and I cracked up. I started laughing hysterically . . . and David, my husband, was holding onto my hand. And I suddenly had this realization, "Oh my God, if I don't stop laughing they'll say I'm too immature to get married and they'll send me home." I thought that was what they were going to do. So I just said, "Boo Hoo," and I made believe I was crying. I figured you were allowed to cry at a wedding. So I was crying "Boo Hoo hoo hoo," but meanwhile I was laughing.[13]

Antin's narrative is a refreshing send-up of the decorum usually endowed on a wedding. As in many of these relationship stories, witnesses proliferate, as Antin describes a scene in which figures external to the relationship monitor her and her union with her husband. Antin responds with the usual irreverence. Not only was the artist in danger of disrupting the proceedings with her laughter, she then dissimulated her own emotions by transforming her laughter into simulated tears. The final scene is one in which emotional behaviors that are typical to wedding stories (smiles and tears) appear in odd ways—slightly off center. The usual authenticity and transparency that are the mandate of sacred ritual are, instead, upstaged by Antin's sense of play and performativity. It is through such narratives, art works, and personal choices that today's artist-couples can diversify the homogenous vision given to Coupledom today and challenge the ways in which couples approach the very presumptions of relationships.

LOVING MEMORY

Couples, like individuals, are ephemeral, *mortal*, and there are several pieces in this show that address (implicitly or explicitly) the project of mourning in relationships, though in very different ways. Patricia Cronin's *Memorial to a Marriage* does not mourn a relationship per se. Rather, the piece gathers together artistic traditions of mourning in order to contemplate public disavowal of her relationship. The bronze is a portrait of Cronin and her partner, artist Deborah Kass, a reduced version of the marble permanently stationed as grave marker at the Woodlawn Cemetery in the Bronx. The two recumbent women lie intertwined on their marble bed, their bodies stretched in the sleep that, in a graveyard context, is a familiar euphemism for death. As Cronin explained, the work acknowledges a permanence in her connection to Kass—an acknowledgment that is denied legal status in a country in which same-sex couples are not allowed to marry:

> It is a memorial to something that can't happen. It is created out of grief, in a way, in that there's a constant level of grief in being unofficial because we're two women. The world is set up for this other kind of thing. So I resolved: if I can't have it in life, I'm going to have it in death. I'm basically trying to find a permanent home. A permanent resting place or home.[14]

As critics have been quick to observe, Cronin's work is an alloy of sophisticated references to nineteenth-century art, ranging from Gustave Courbet's erotic paintings of lesbians woozy in postcoital relaxation, to the marble heroines of American expatriate sculptor Harriet Hosmer (whose work Cronin has helped return to the attention of art historians). But while the work is a mix of art-historical references, as well as a powerful protest against interdictions on gay marriage, it also commemorates the poignant fatality that has traditionally befallen same-sex couples in visual culture. As is amply demonstrated by the notorious necrology of Vito Russo's *The Celluloid Closet*, a history of gays and lesbians in the cinema, characters that express desire for those of the same gender are typically

killed off as a means of resolving narrative crises in film and literature.[15] Committing suicide or suffering violent deaths at the hands of hustlers, gay and lesbian characters have historically been too transgressive to be allowed a happy ending. Cronin's self-portrait with Kass serves as a memorial to this history—to these characters—as well. It commemorates the long history of erasure and denial that gay men and lesbians have endured, only to receive a death sentence, in our visual history.

Other works in *Couples Discourse* contemplate the social rituals by which one mourns a relationship. Some months after artist and scholar Deborah Willis and her husband, Winston Kennedy, were invited to participate in the exhibition, Kennedy informed her that he had decided to end the marriage. Choosing to confront this life-change as a source of inspiration for her work, rather than as an impediment to it, Willis began making pieces that engage the process of *uncoupling*—the gradual and complicated disentangling of one life from another. The diptychs from her *Mother Wit* series present photographs of personal objects alongside gravestone-shaped glass panels that have been inscribed with folk sayings typically shared among women about men in relationships. Next to the image of a pair of shoes, for example, a quotation reads, *"Never buy a man a pair of shoes, 'cause he'll just use them to walk out on you."* The other quotations are similarly precautionary. Never buy a man a coat. Never let him cut your hair. One might properly call these statements epitaphs, rather than quotations, for they are short proverbial writings that set an interpersonal connection apart as something that has passed away. "Here lies my marriage," each of Willis' epitaphs implicitly laments.

At the same time, however, these sayings invert the usual temporality of such inscriptions in that they anticipate rather than remember a relationship: They are prescriptions for behaviors that may possibly avert (but always anticipate) abandonment. And each of the epitaphs speaks, rather painfully, about the social aspect of couples. Willis' former partner hardly appears in this work except as a gen-

eralized "man"—one of an anonymous group whom one should not award with generosity. Rather, these pieces seem more interested in the community of women through whom Willis feels she might have learned to prepare for this ending. These are the women through whom, in other words, Willis has triangulated her relationship. In her statement about the work, she makes poignant reference to rules, an implicit code of conduct articulated by these women that Willis suggests she betrayed:

> I used to hear the women talk about male/female relationships I broke the rules when I did not adhere to the following: Never let a man cut your hair, 'cause he will keep a bit of your spirit. Never buy a man a coat, 'cause he will keep another woman warm with it.

Such self-deprecating inversions of responsibility (I wonder if I, rather than my partner, made the mistake here. I wonder if I shouldn't have paid more attention to my community of women, rather than to one man) will probably be familiar to anyone who has gone through the process of mourning a lost relationship—and such collective familiarity is an important part of this piece. Not drawing on published, scholarly knowledge, Willis references unofficial traditions of womanly advice similar to the precautions and lamentations that one might hear in the lyrics of a blues ballad. In the process, she turns a very personal experience into a collective one.

And, of course, for artists who have proven the vitality of recto/verso relationships, for those artists who have permitted each other artistic independence even when their lives have been separated only by paper-thin distances, the death of one partner can be especially painful. At such a time, the process of mourning becomes all the more necessary, and the community of witnesses that has celebrated a couple yearns to memorialize it as well. The organizers of this exhibition therefore hope to join Nancy Spero in remembering and celebrating the extraordinary contribution made by her husband,

Leon Golub, who passed away in 2004. Through fifty-three years of marriage, Golub and Spero famously demonstrated the ways in which couples compound their energy and invigorate each other's creative power when working side by side. Their shared commitment to unrestrained social commentary helped instill a sense of political responsibility among artists of the postwar era, and their example of personal partnership will remain an inspiration to us all.

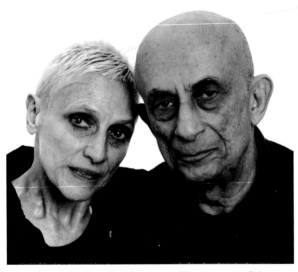

Nancy Spero and Leon Golub in 1994. Photo courtesy Galerie Lelong, New York

1 See a brief discussion of their collection in Carol Diehl, "Birds, Beads and Bannerstones," *ARTnews* 95 (Summer 1996): 79.

2 See, for example, Betty Woodman, "The Painted Garden: An Interview," *Studio Potter* 27 (December 1998): 44–65.

3 George Woodman, "Ceramics and the Biography of Vision," *Studio Potter* 17 (December 1988): 36–37.

4 Taken from Katy Kline and Helaine Posner, "A Conversation with Leon Golub and Nancy Spero," in *Leon Golub and Nancy Spero: War and Memory* (Cambridge: MIT List Visual Arts Center, 1994), 31.

5 Max Kozloff, as quoted in *Crossed Purposes: Joyce & Max Kozloff*, Interviews by Moira Roth (Youngstown: The Butler Institute of American Art, 1998), 9.

6 For a summary of recent debates surrounding political and cultural definitions of "the couple," see the special marriage issue of *The Nation*, July 5, 2004, 13–46.

7 Roland Barthes, *A Lover's Discourse: Fragments* (New York: Hill and Wang, 1978), 37.

8 Roland Barthes, "Conjugations," reprinted in *The Eiffel Tower, and Other Mythologies* (New York: Hill and Wang, 1979), 23.

9 There have, of course, been important historical investigations of artistic Coupledom that have focused on relationships between artists in the nineteenth and twentieth centuries. See, in particular, the important essays collected by Whitney Chadwick and Isabelle de Courtivron, *Significant Others: Creativity and Intimate Partnership* (London and New York: Thames and Hudson, 1993).

10 This connection between the commercial and the matrimonial within the visual media comes with a long history. For a remarkable study of the ways in which images of marriage have been recruited for commercial ends, see Eva Illouz, *Consuming the Romantic Utopia: Love and the Cultural Contradictions of Capitalism* (Berkeley: University of California Press, 1997). See also Phillip Vannini, "Will You Marry Me? Spectacle and Consumption in the Ritual of Marriage Proposals," *Journal of Popular Culture* 38 (August 2004): 169–85.

11 Judith Halberstam, "Pimp My Bride," *The Nation*, July 5, 2004, 44–46.

12 Used as illustrations for Wendy Goodman, "A Separate Peace," *New York Magazine*, April 9, 2001, 48–53.

13 Eleanor Antin in an interview for the PBS program *Art: 21—Art in the Twenty-First Century*, program number 8.

14 As quoted in David Frankel, "Liebestod," in *Patricia Cronin: Memorial to a Marriage*, exhibition brochure, Grand Arts, Kansas City, Missouri.

15 Vito Russo, *The Celluloid Closet: Homosexuality in the Movies* (New York: Harper & Row, 1981).

statements

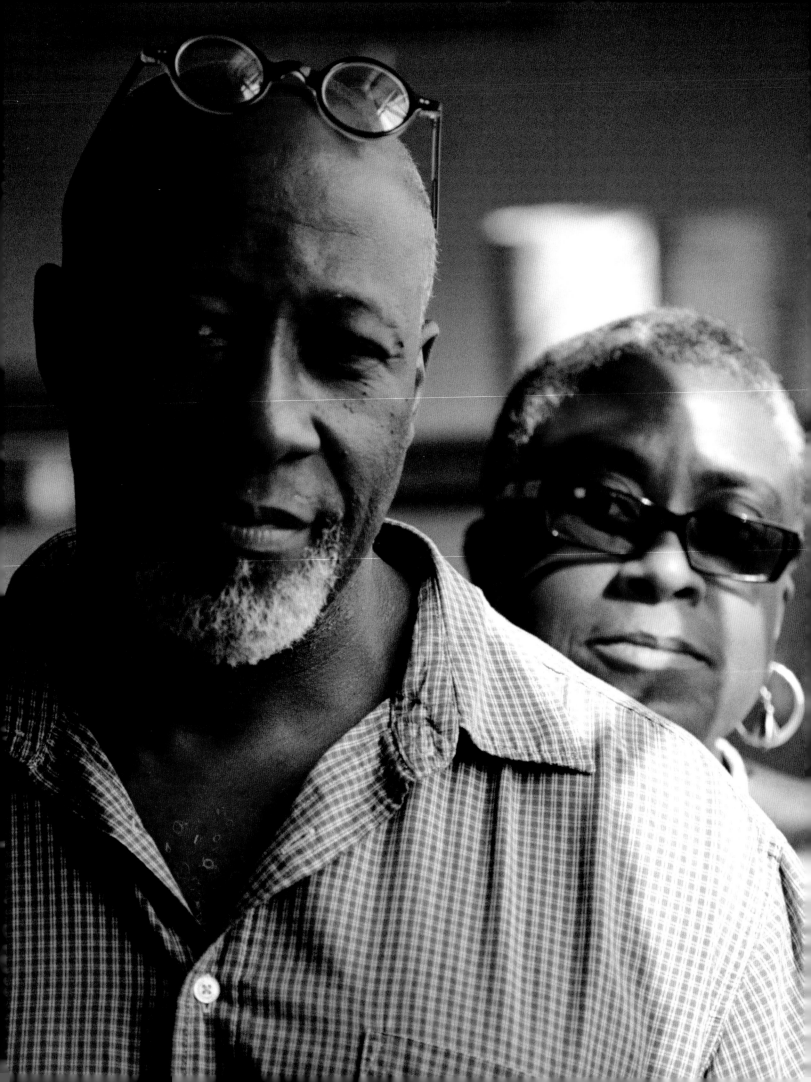

Arlene Burke-Morgan
Clarence Morgan

Clearly there are similarities between our sensibilities given our mutual interests and experiences over the years. Perhaps focusing on the ways our work is different would be more revealing and ultimately enlightening about what we share. Yet, to discuss material and formal idiosyncrasies in our work seems to shed very little light on who we are as artists and why we were destined to be in a lifelong relationship.

It seems inevitable that one's work changes over time, and those shifts ultimately correspond to the natural ebb and flow of our personal evolution as individuals. Hence, looking at the world through the eyes of a 22-year-old is very different once those same eyes have matured. Relationships affect many things in ways unimaginable and unpredictable. Naturally, we share many of the same values, dreams, and visions, which, needless to say, contribute to our compatibility as an artist-couple.

It is indeed rare when passionate creative pursuits can be truly shared by two individuals who are at the same time romantically infatuated with each other. Our personal work as artists has helped to deepen our partnership, and that domestic partnership over the years has nourished our practice as artists. Living the life of artists doesn't seem to be consistent with following a pragmatic approach where facts are the only thing that count. We seldom engage in critical discussions of each other's work. However, on occasion there are natural curiosities, well-placed compliments, and poignant observations about a particular work or significant shift in a familiar process.

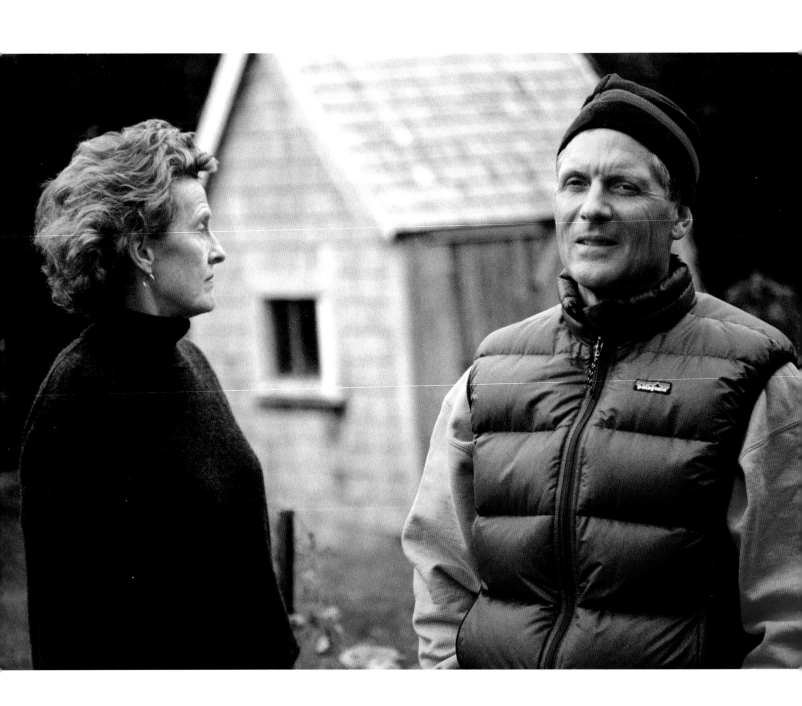

HELEN MIRANDA WILSON
TIMOTHY WOODMAN

The similarity in my work and Helen's is that we both put paint on surfaces. In the past we have both worked in a representational style, but currently Helen is working in an abstract mode. The main difference in our work is that I paint on three-dimensional supports (sculpture), and Helen paints on flat surfaces. Helen seems to have less of a problem than I do with the issue of "what" to do a painting of.

Our work is our own, and thus there is no problem with opposition to each other's ideas. We both respect each other's need to work. Over time we have figured out ways to take care of private responsibilities in a mutual way.

I often solicit Helen's criticism of my work. Her observations are usually apt, and she often makes helpful suggestions. The main advantage of being an artist-couple is that the other person understands what it is all about. I don't know of any disadvantages to being part of an artist-couple. The disadvantages of being an artist are one's own.

Helen adds: We have lived together for thirty-six years, most of them on a low budget. We have always shared the domestic chores and household expenses equally. Because of this, our many homes have been a haven in which we can produce our work. Professional and emotional support is important, but, in the end, it's less crucial than hot food on the table and knowing that I won't have to pay for more than my half of things. That said, I would love Tim's sculpture even if we'd never met; it's brilliant! He can work through anything. Visiting his studio feels like holding my hands up to a warm fire on a cold night.

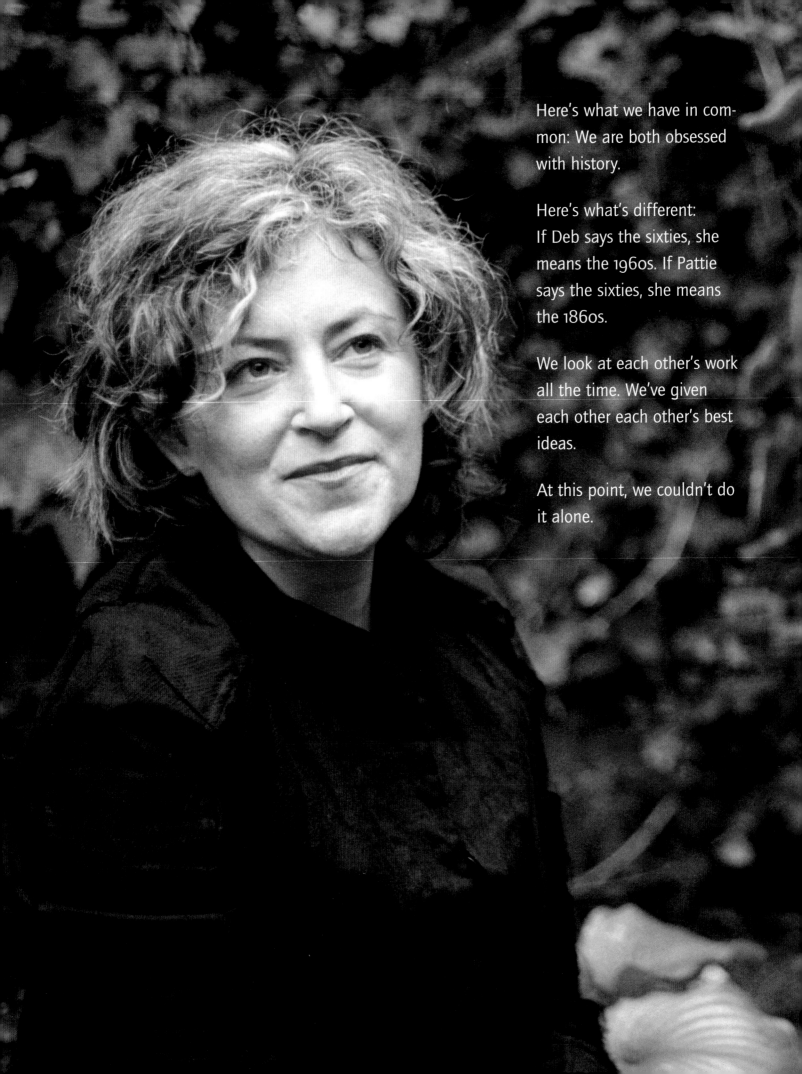

Here's what we have in common: We are both obsessed with history.

Here's what's different: If Deb says the sixties, she means the 1960s. If Pattie says the sixties, she means the 1860s.

We look at each other's work all the time. We've given each other each other's best ideas.

At this point, we couldn't do it alone.

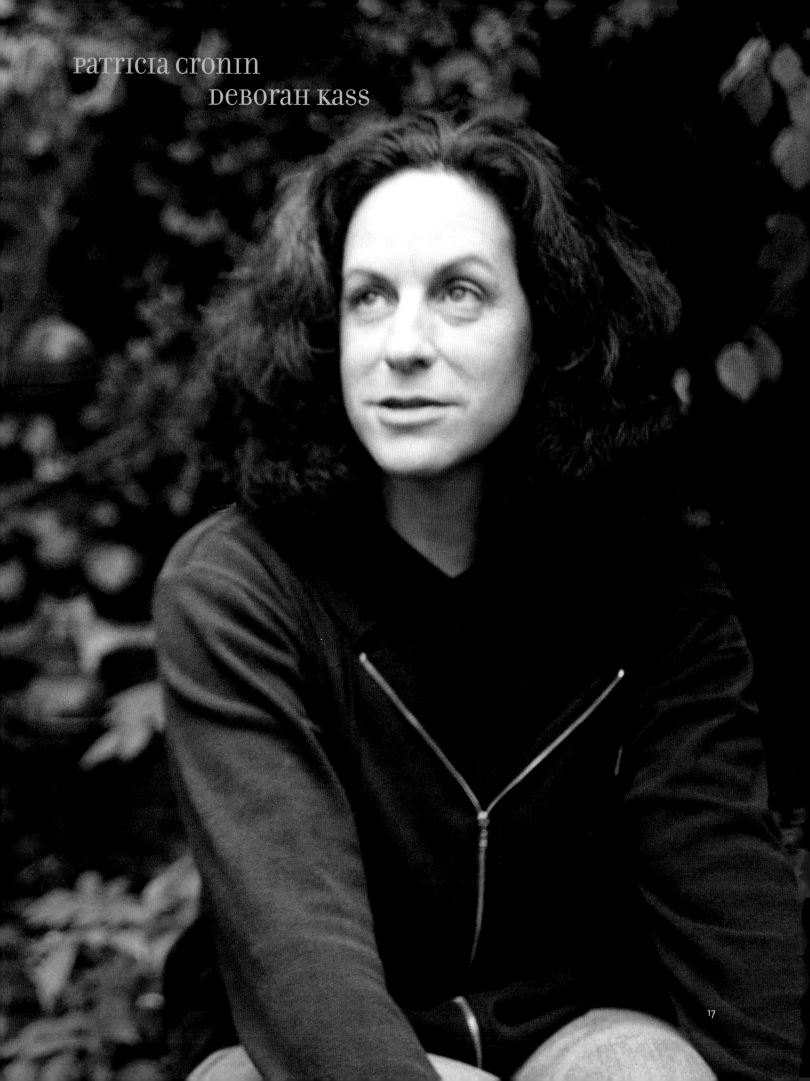

17

DAVID I remember one day Elly walks into the room where I'm typing something and asks me, "What do you think about a hundred boots facing the sea?" "I don't know," I said, "I haven't thought about it." I was used to Elly pulling rabbits out of a hat, and I figured pretty soon she'd show me the hat. And she did. We were living in a little old stucco and tile house in southern California, perched on a bluff over the beach. It had a terrace that let you look seagulls in the eye. She led me out to the terrace and pointed down to the beach. "There," she said. "I like it," I said. "I thought you would. It came to me last night." I did like it and knew what she meant. Somehow she was going to use the image—probably in a photograph—of a hundred boots on the beach seen from some distance behind them—maybe from our terrace—looking out to sea. I didn't know where she'd get a hundred boots or what she would do with the photograph once it was made, but I knew she'd figure that out. And she did. That's the way she works. Elly goes along quietly looking at pictures and books and dreaming until an image pops into her head—a kind of Pandora's box from which all the trouble unfolds.

ELLY Yes, it's like "more lemons" suddenly leaping off the page of Stendhal's journal, or Sappho's apple. She's reaching high up into the tree to pull it down, but she can't... the poor thing is too short like me. And suddenly, Atalanta's would-be lover throws it, that same apple, into the race, and she succumbs, too. How can she resist its delicious flesh, its redness? Like Adam, she falls. The poetry of transformations, layers of meaning turning on themselves—that's how I've always made my art, whether it was political or psychological or, as I find myself now, more existential, more into the death of things. David, now, he's different. I've called him a classicist before. He thinks before he talks. Can you imagine that, thinking before you talk? It's marvelous, I would forget what I thought by the time I opened my mouth. But thought is elusive; it doesn't come 1-2-3, with a beginning, middle, and end. So David is sneaky, too; he doesn't give himself away, he's the last of the Mohicans, that guy. He's a trapper following the tracks; his thoughts are lying before him, silently coming up on them to get where they're leading, stopping under a tree to relax, take a drink, remember a story, a joke, but never forgetting the journey, always coming closer, tighter, until he's out of the forest, which opens up to reveal itself. And damn it, if it wasn't there all the time from the beginning. The way in becomes the way out. He hasn't caught anything, but he's found out where he was going all of this time. And I'll tell you a secret: He never knows if he'll get out of that forest alive. Remember he's out there in front of an audience. He has to keep going, although I'll tell you another secret. I've seen him retrace his steps, go back and start again,

ELeanor antin
DaviD antIn

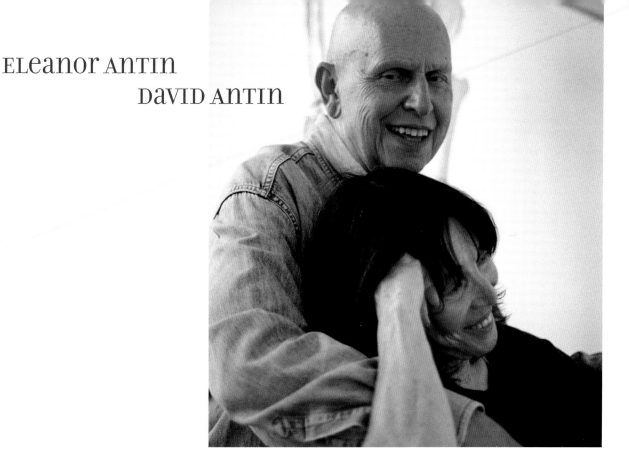

and he's such a wily son of a bitch, nobody realizes it, because
they're enjoying the trip so much, they're lulled by his courage—
or is it his chutzpa? They're so confident that he'll make it, he'll
take them with him and they'll get there together, they'll come
out of that damned forest alive. And they do, they always do. And
he lives to see another day

DAVID Elly makes my way of working sound more dramatic than I feel it
is. I tend to think that I usually arrive at some kind of snarl of
ideas, a kind of linguistic or logical traffic accident, and I try
patiently to work my way out. Elly is more explosive. She has an
ongoing lover's quarrel with history that intermittently breaks
out into full-scale spats. She's always going over it, looking for
what it left out or never got quite right. A couple of years ago she
was planning a take on grand opera, which I think she saw as a
photo shoot that would run its images of passion through the
chilling screen of contemporary photography. The frozen arias
never happened. She started reading a book about Atlantis, which
was really about the volcanic destruction of Thera and the subse-
quent collapse of the affluent and peaceful Minoan empire.
Living in the affluent but not so peaceful American empire, she
jumped to rich and violent Rome, and the Pompeii photographs
were born.

ELLY That David! He always likes to be so cool! Traffic accidents aren't
dramatic?

DAVID They may be, but they happen every day.

BENNY ANDREWS

Our work has evolved over the twenty-six years we've been together, but the essence of what, why, and how we express ourselves as artists has remained constant.

Underscoring our professional lives as an artist-couple are a sixteen-year age difference and two very different approaches to making art.

Benny's oil and collage paintings are figurative narratives drawing on his personal history. Nene's work is three-dimensional and abstract with its conceptual underpinnings concerned with the body and its relationship to the world. Consequently, we inhabit two very different art worlds. When a critic, curator, or collector comes to Nene's studio, he or she is rarely interested in Benny's work and vice versa. We have rarely exhibited together.

The advantages of being an artist-couple are many. A primary advantage for us is having a partner who is focused, speaks the same language, completely understands your obsession, and is as totally committed to making art as you are.

The disadvantages are few, though significant.

Artists tend to have strong egos, and we are no exception. We are both very competitive and opinionated, so living together is not always easy. There are times when we realize that we just have to back off when we disagree or when one's work is going well and the other's isn't … when one needs to get away from the studio and the other wants to be there twenty-four hours a day.

There is often a need to sit down and negotiate how to handle our professional schedules versus time spent together. We are both very aware that "career" can all too easily swing to the forefront, leaving the personal relationship behind.

Through the years we've worked out an equitable way of sharing the workload of daily life—shopping, cooking, etc.—and we make it a point to have dinner with each other as often as possible, even if that means late at night after openings or lectures.

We have always had completely separate studios: most recently, one floor divided into two equal spaces, each furnished with a pair of mobile earphones. One does not come into the other's studio unless asked, and then we converse rather than critique.

*What are the similarities and differences
in your work and methods?*

Brice is cerebral and Helen is more spontaneous.

*How do you navigate through times when your
work is in opposition to each other's ideas?*

We have been together thirty-eight years.
We have always been in opposition.
What could be more interesting?

*Have your attitudes toward your work
changed over the years and how has your relation-
ship affected those changes?*

They have become more intense or maybe more
flimsy and less concerned with the outside.

*How do you settle issues involving professional
and private responsibilities?*

Professional and private do not separate.
We are not bankers.

*Do you ask for your partner's criticism of
your work? Why or why not? Can you comment
on those interactions?*

Yes, we ask criticism from each other.
This dialogue sustains us. This is our life.
We are painters—art is our overwhelming
passion and interest.

*What are the advantages and disadvantages
of being an artist-couple?*

There are no disadvantages.
We would not know the alternative.

*Are there artistic and/or theoretical dialogues
evident in your work?*

No.

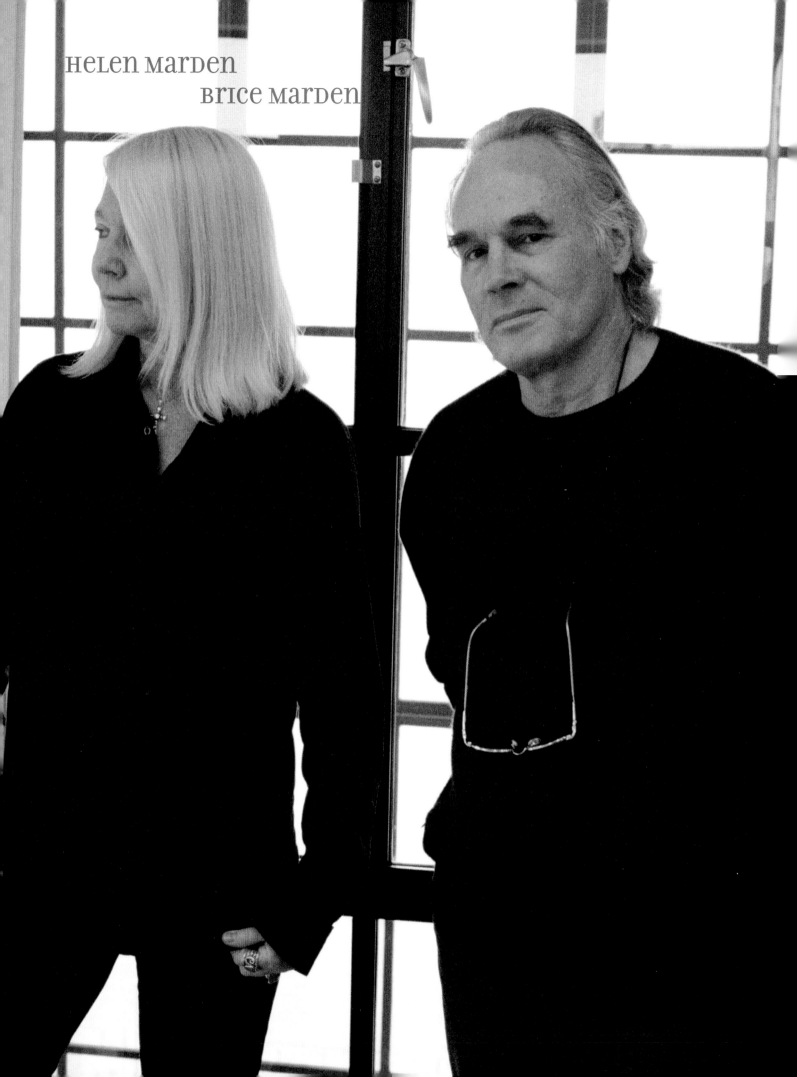

HeLen MarDen
BrICe MarDen

Couples Discourse or

Folie à deux?

Folie à deux is a rather effective French epithet describing "a madness shared by two." Within the definition of mental disorders, *folie à deux* is exempt from the category of psychosis when the shared mental aberration is commonly accepted by one's immediate culture. Within our practice of visual art and within the cultural community of institutionalized imagination, we merge fiction and illusion with critical considerations as ways to know the world.

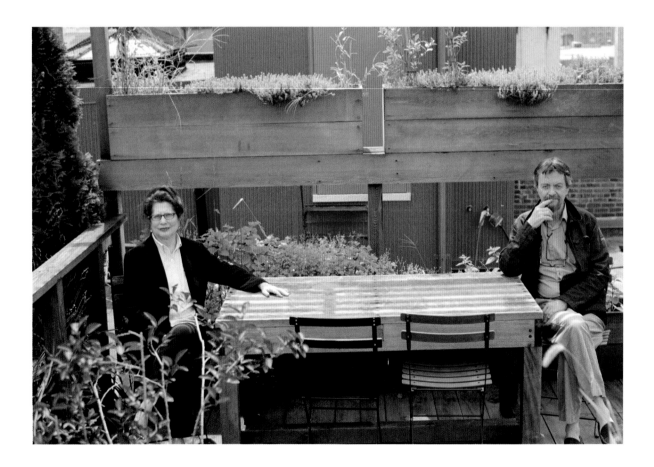

suzanne anker
frank gillette

Does our madness
support each other?

Perhaps as a *pas de deux*.

How does such emotional contagion affect our mutual work? Deeply resonant and extremely intense psychic connections morphogenetically connect our attitudes of mind. Proceeding from issues and ideas stemming from the natural world, our work shares an affinity with questions and contemplations concerning life in its myriad configurations of forms. It is within this domain that our interchanges take full-tilt expression. Because we are two distinct and separate parts of an intimate whole, resolution is always individually navigated. Differences abound, but commonality of purpose ultimately trumps territorial and ideological persuasions. Formal issues of beauty and the monstrous intersect with the greater cultural surround consumed by the dynamics of chance and necessity.

To be an artist is to speak in tongues and to share that illusionary space is a profound experience. Although our work and methodologies overlap within the digital realm, the sense of time is substantially different in each. For Frank, measuring time is part and parcel of his practice—overlays, seamless collages, and disjunctive cross-references. For Suzanne, the sense of time is based on an instrumentalized scientific vision, as numbers turn form into matter.

Pas de deux, folie à deux … what's the difference? It is simply this: a dance of interlocking contrasts with non-overlapping concerns, with differences providing structural shifts of emphasis. Concluding in the end with two independent bodies of work, but nonetheless requiring a reliance on mutual affirmation.

Calling our interaction a "discourse" both over- and understates the actual case. In the zone of our studio activities, the reality is more a kind of parallel play, episodically interrupted by observations and criticism. The practicalities and logistics of day-to-day life fill up the other time, with ideas and feelings about art and the art world woven continually into a larger fabric. It can be comforting to be intimately connected to someone whose interests and goals are generally similar, and it also provides a partial inoculation against the narcissism whose tidal pull is one of the artist's chronic occupational hazards.

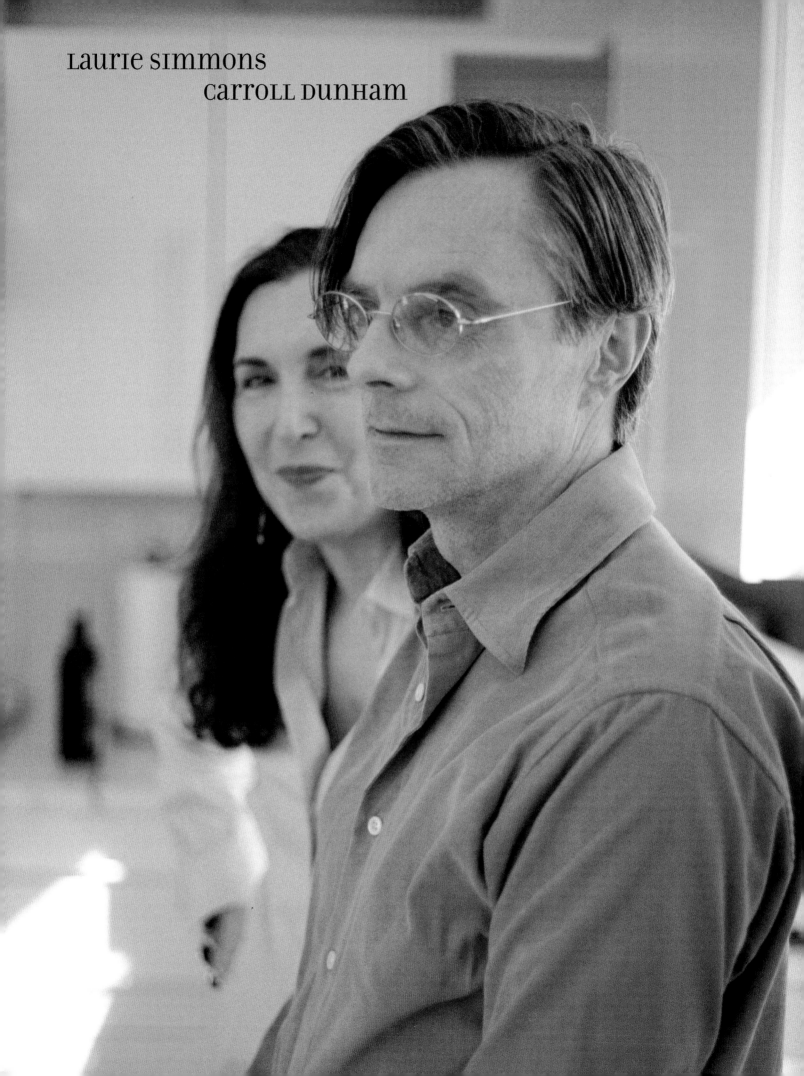

LAURIE SIMMONS
CARROLL DUNHAM

Julie is a painter.
Cathy is a photographer.

We share a common sensibility and lots of ideas about what is beautiful, thought provoking, and important. Our practices are very different, however, because of the inherent differences in our chosen mediums. In addition, the theoretical and artistic dialogues that exist in our work seem to be fairly individual. Cathy's work is more concerned with documentation and community; Julie's work is more abstract and personal.

We tend to "run" things by each other, and sometimes these ideas are met with less enthusiasm than others, but we are always mutually supportive. We both ask for feedback, but only when we feel ready—we always ask if a studio visit is welcome or should be planned later.

Being in an artist-couple is very satisfying. We can teach each other about new artists and also about specific sensibilities within each of our mediums. I would say that being artists offers built-in support and criticism—very necessary components. Of course, our professional and private responsibilities keep us on our toes and definitely are the reasons behind much serious schedule juggling.

JULIe BURLeIGH
CATHerINe OPIe

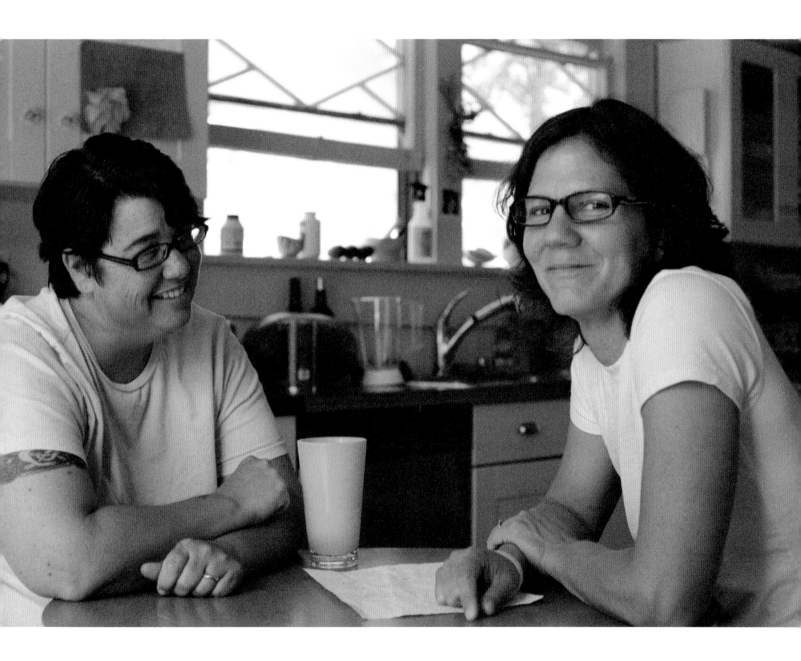

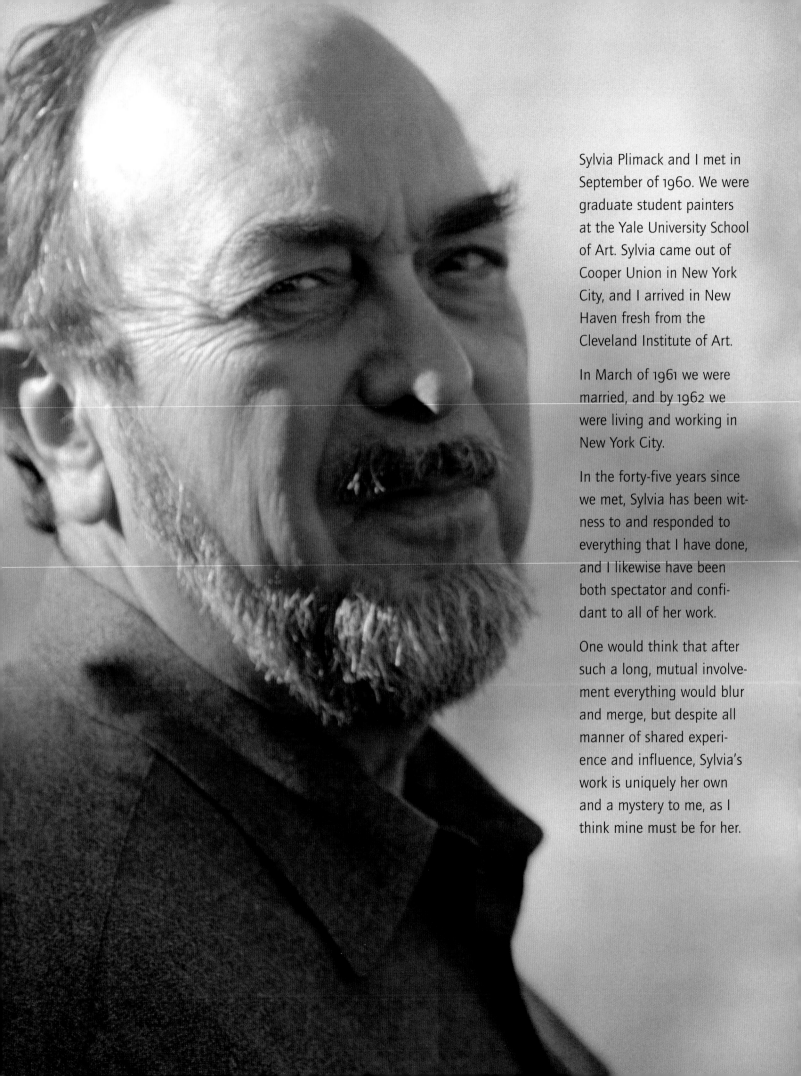

Sylvia Plimack and I met in September of 1960. We were graduate student painters at the Yale University School of Art. Sylvia came out of Cooper Union in New York City, and I arrived in New Haven fresh from the Cleveland Institute of Art.

In March of 1961 we were married, and by 1962 we were living and working in New York City.

In the forty-five years since we met, Sylvia has been witness to and responded to everything that I have done, and I likewise have been both spectator and confidant to all of her work.

One would think that after such a long, mutual involvement everything would blur and merge, but despite all manner of shared experience and influence, Sylvia's work is uniquely her own and a mystery to me, as I think mine must be for her.

SYLVIa PLImack MaNGOLD
ROBert MaNGOLD

WENDY EDWARDS
JERRY MISCHAK

While contemplating questions relating to our work and our relationship for this exhibition, we found ourselves folding laundry and eating scrambled eggs. Our work falls within a repetitive system of layering. Wendy manipulates paint into long, stringy, net-like webs, and Jerry rips and wraps tape around objects that he has either built or found. Our methods of working seem similar as processes of continuity; we are involved in obscuring surfaces within layers. The differences come predominantly in our approaches to material and color. Jerry selects tape of already existent colors, developing a thick, dense crust of opaque color, while Wendy physically mixes paint colors, and works with transparency and light. Jerry's work is dependent on the form he is covering and protrudes three dimensionally from a skin-like surface. Wendy uses broad brushstrokes on the first layers or screens of color and then separates the space by kind of writing on the top.

We don't find any problems in terms of navigating through times when our work differs; it never seems to be in opposition to each other. We embrace the idea of difference and love each other because we aren't in the same studio. Both our work and our attitudes have changed a lot over the years. Determining whether the ups and downs in our lives are evident in our work is hard to perceive given the complexity of the transitions we make in regular everyday life.

Our professional and private responsibilities are divided in that we help one another whenever we can, but we are independent when it comes to exhibiting our work, with the exception of this exhibition, which at this moment has pushed us to examine our relationship more than usual. Every once in awhile we ask each other for opinions, but the best exchanges are when we haven't been in each other's studio for a month or so … when we are surprised by something new that is really exciting.

Our lifestyle is a given at this point; neither of us can imagine not being with another artist. We both understand our working schedules and balance studio time with real life things like enjoying cooking and being in bed together. We visually share looking at new work in museums and galleries, enjoying new environments as a time to bounce ideas and opinions off each other.

BETTY WOODMAN
GEORGE WOODMAN

We work in very different materials and with different approaches in terms of planning, working out ideas, accepting chance, etc. But there are more fundamental similarities. We both make things to look at. The large heritage of art is an important source of ideas, values, and support for us. We both need the critical challenge of being in touch with current art. We both feel that continuous and sustained work is what we want to do as artists and how to arrive at what we want to make. Regardless of differences of personal style, the ethos of our work is shared. Going to museums together is an important part of our "method."

Our attitudes toward our work have broadened, become more informed, and indeed changed over the years. Each of us has encouraged and been supportive of change for the other. We each try to manage our own affairs, but we rely on each other a great deal because we each have certain skills that the other may have less or more of.

We expect each other to be aware of and responsive to the other's work, and we try to help each other to "see what's there." This is done frequently and carefully. We attempt to help each other deal with specific uncertainties. We admire each other's work and enjoy seeing it, for it is stimulating to always have some fresh and surprising work nearby.

The advantage of being an artist-couple is to have a partner who can appreciate and support the complex life of an artist. The disadvantages are moments of envy, distraction, and the doubling-of-art chaos. While we think there certainly are artistic and theoretical dialogues in our work, we are not sure how evident they are, and we are not about to try to unravel them. This would be a good Ph.D. thesis for a young scholar.

We don't work collaboratively, but of course we respect each other's work and have some important things in common. We're both quite romantic about the nature of art. We're not ironic. We're both interested in portraiture, and we're both bad at networking and other career-building tasks. We differ in that Paul is extroverted, and his work reflects that. I am not. Paul photographs out in the world, while I stay in my studio and mainly paint myself. He's spontaneous. I make plans and schedules.

Our biggest impact on each other comes from having a child together. Of course this would be the case whether or not we were artists. Obviously a lot of negotiation and compromise is involved here, as well as a change in worldview (we're no longer the center of the universe, etc.). Time is now very precious, and we haggle over it a lot.

We sometimes criticize each other's work. Paul often asks me to look at work prints to help edit or sequence. I am more reserved, and usually don't want his input unless I'm hopelessly stuck.

In terms of issues involving professional and private responsibilities, it's give and take. Such as, Paul gets to go surfing in Hawaii in December if I can go to New York in January (this happened last year). We do a bit of tag-team parenting. Sometimes we don't settle issues; we just argue about them.

As far as the advantages of being an artist-couple—we understand each other's motives. We both grapple with the tricky relationship between artistic aspirations and career goals. We accept that we aren't and won't be rich. We share the light table. Disadvantages? We won't be rich, and we have to share the light table.

ANNE HARRIS
PAUL D'AMATO

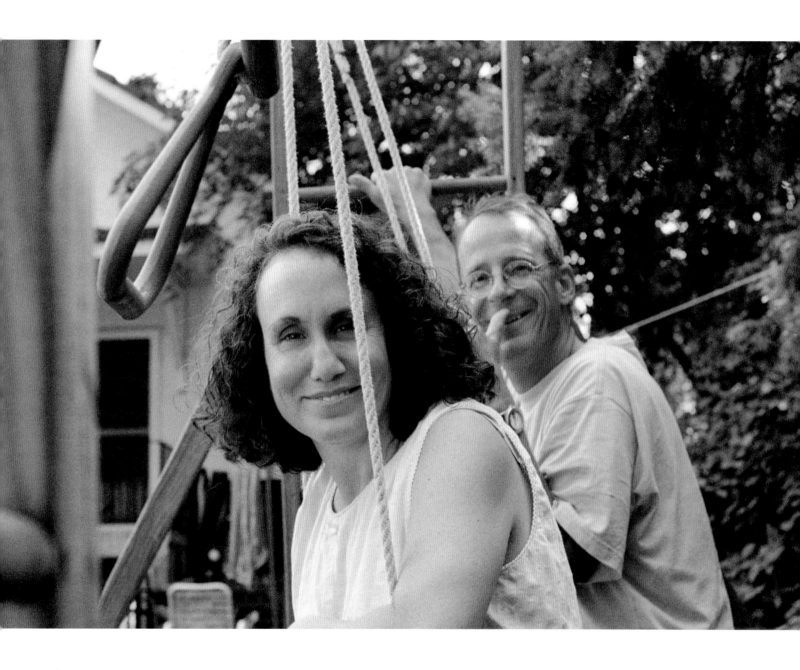

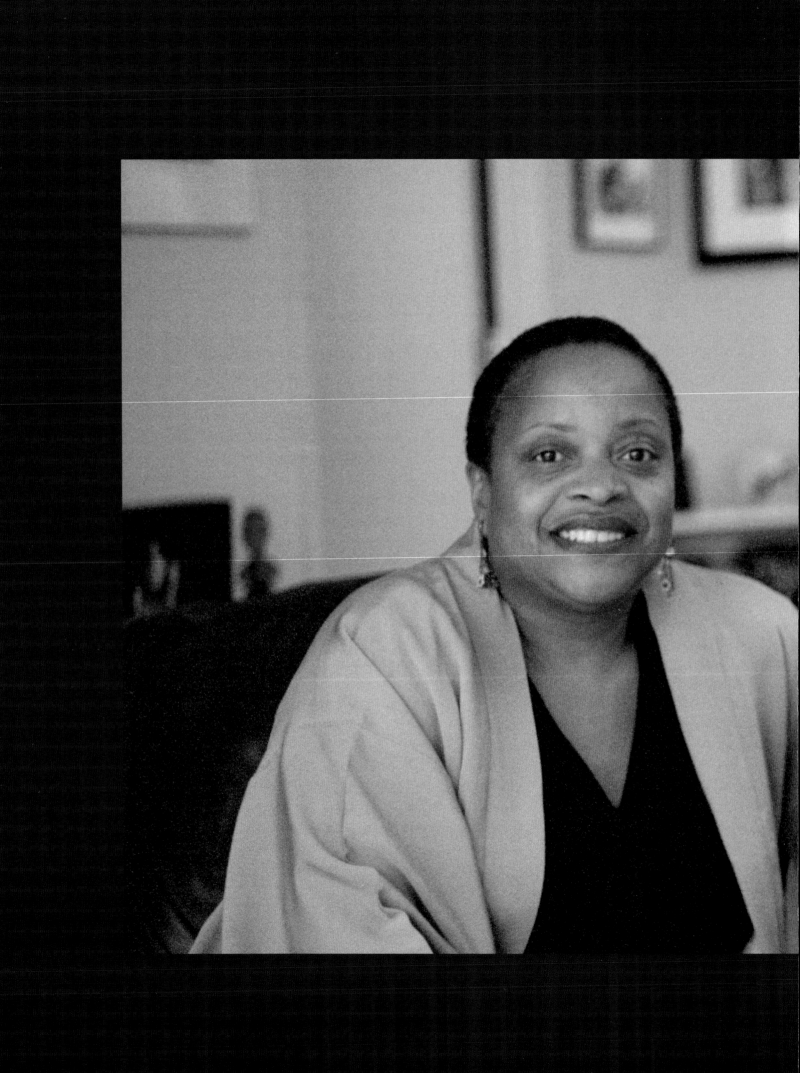

Deborah Willis

I grew up in North Philadelphia in the 1950s and '60s listening to mother wit: the stories my grandmother's grandmother passed on to her daughters, who in turn passed them on to my generation of women. I quietly believed most of what they said, but I "knew" better, so I would listen and smile to myself. When they talked about marriage, I would say to myself, "Oh, no. I don't believe that. I am gonna be open and giving to my husband."

On Relationships:
I used to hear the women talk about male-female relationships
I broke the rules when I did not adhere to the following:

Never let your man cut your hair, 'cause he will keep
a bit of your spirit.

Never buy a man a pair of shoes, 'cause he will walk
all over you or he will walk away from you.

Never buy a man a coat, 'cause he will keep another
woman warm in it.

I broke grandmom's rules and bought my man a pair of
shoes and he walked away; I let the man cut my hair
and he took a bit of my spirit; I purchased a coat,
and now he is keeping another woman warm . . .

We met each other in school, and it was love at first sight for both of us. CalArts in the early 1970s was a wonderful place to be, and our mutual desire to become artists connected us deeply. We decided that we would go out into the big world together, socially integrate ourselves, but never assimilate. We were then, as now, liberal, atheists, and, as homosexuals, haughty, protective, and excited by our identities. Quite simply, we have always shared the same values, and perhaps that is why we recently celebrated our thirty-second anniversary.

Although we are from very different backgrounds, we were acquirers as children and are voracious collectors as adults. We have collected Latin American Colonial art, African art, textiles, ceramics, furniture, and modern and contemporary art in depth. We keep track of every object, keep them in our thoughts, refer to them often in daily conversations, and quote them directly and indirectly in our work. Over the many years, the aesthetic articulation of our home and studio has been an overarching concern and focus. This concern is both personal and ideological. We understand for ourselves, as a completely artificial construction, the mutually inclusive relationship between beauty and safety. Although we have always maintained a physical separation of our home and our studios, they are equally subjected to ongoing arranging and display of objects. This brings us much pleasure and happiness, and cultivates a curious restlessness that often suggests the discussion of mortality. Although possible at times to sublimate, we give it free reign in our work.

In the last five years, our garden has become an increasingly important collaborative activity. We set aside a large plot of land to design and landscape with cactus, aloes, agaves, and succulents. Against gardening trends that emphasize simulated naturalism, we decided to use a more rational and ordered approach. Using "parterres" to segregate large mass plantings of the same species, one ironically becomes more aware of the formal structure, color, and movement of each plant. We each have an internal compositional order that manifests itself in our work, and it has been exciting to see it imprinted in our garden. Differences in our personal temperaments and aesthetic sensibilities are clearly manifest in the garden and produce different physical experiences. Some areas are clearly theatrical and extroverted, and some areas are private and contemplative. Many times the same plant is asked to accommodate these differing dynamics. Even though order is at first apparent, relativism is the garden's true text.

The artist-couple, like any couple, cobbles together a life from shared experiences. Within a fundamentally mundane existence, meaning and aesthetics are willfully created and deployed. Eventually, it is only our singularly defined activities within our respective studios that somehow address an aggregate of experiences.

ROY DOWELL
Lari Pittman

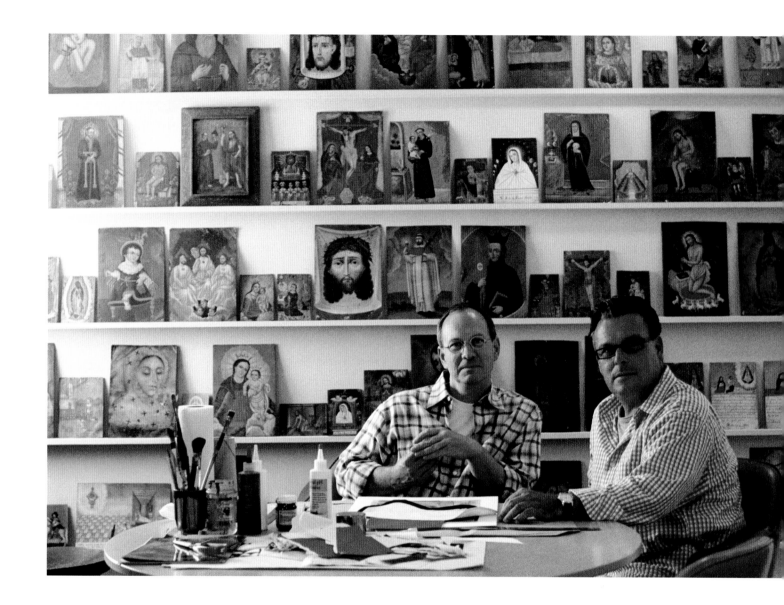

The artist-couple, like any couple, cobbles together a life from shared experiences.

Within a fundamentally mundane existence, meaning and aesthetics are willfully created and deployed.

Eventually, it is only our singularly defined activities within our respective studios that somehow address an aggregate of experiences.

Jim and I don't discuss our work with each other—never have and never will. Both studios are under the same roof, although on different floors. During non-painting hours we are in and out of both of them all the time, so we are very well aware of what the other is up to. I can't remember any "discussion" about the work even from the start of our relationship. One might question how something is done, but not the reasoning behind the content. We both have always used the invented image, but any like-ness ends there since our methods are com-pletely different. His preferred mediums are acrylic on canvas and graphite on paper; mine is watercolor.

I think the very good thing about being an artist-couple is that the other half knows what you might be going through with deadlines and such and can step in and assist in the most simple ways—like fielding phone calls, doing the laundry, or cooking dinner....

In short, for us, being part of an artist-couple means, "Don't bother me, I am painting, but come in and see what I have done when I am not doing it ... and, by the way, did you take out the garbage?"

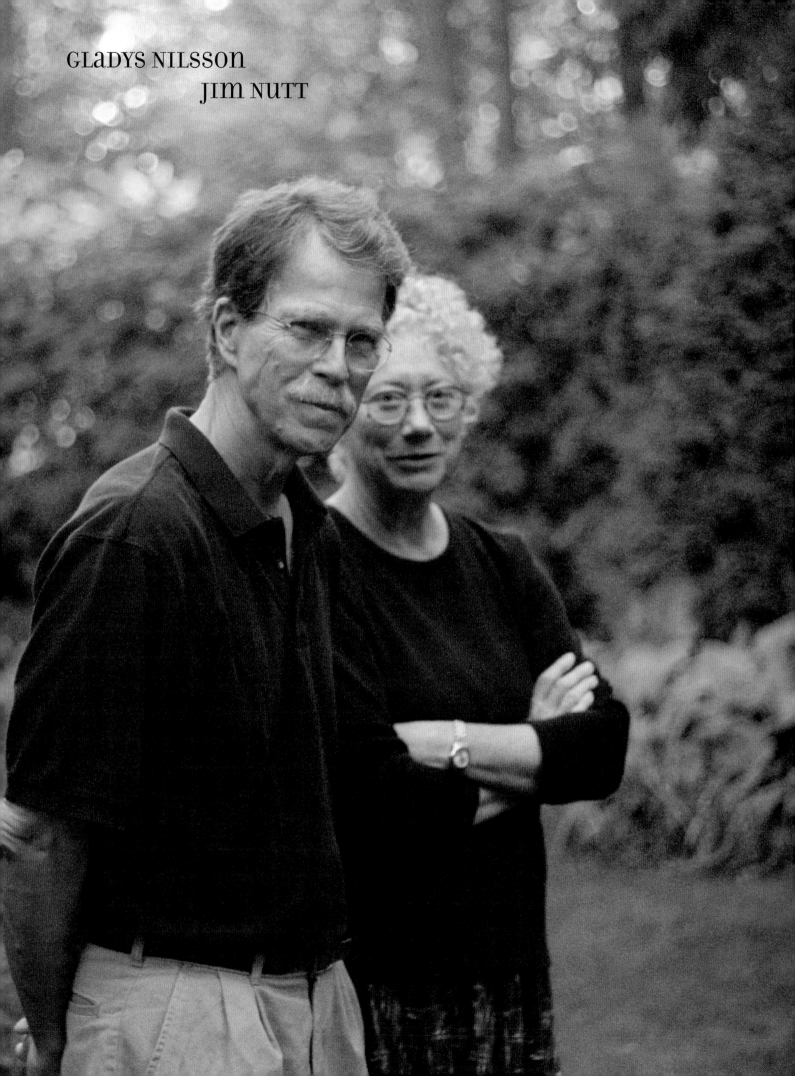

GLADYS NILSSON
JIM NUTT

JUDITH RAPHAEL
TONY PHILLIPS

As a couple we have endured because of our mutual respect for each other's character, substance, and art. We help each other, and we look out for each other's interests. We complement each other both practically and emotionally in a host of demonstrable and invisible ways.

Our studios are shared: one large space with a short wall between us that does not completely enclose either space. We enjoy mutual pleasure in having someone there, sharing occasional talk, some music, and companionship. But we can get on each other's nerves. One's choice of music may annoy the other, and there are times when one's mere presence may irritate the other.

As different from each other as we may be, we share a strong core of values. These are mutually tenable enough that we aren't inclined to get into serious trouble on principle. Our philosophical grounding fits our emotional framework. Our political, social, and aesthetic views are close enough for our mutual comfort and support, but just different enough to make being together interesting and usefully challenging.

We both use the figure to address the human condition, and for many years we have both worked from psychological musings about our perception of the interior world of people.

For the last half-dozen years, Judith has worked primarily with images of girls as subjects through which she examines the myths and reality of gender. She has a huge photographic file from which she invents. These files are culled from contemporary images, art history, family photos, and any other documents that propel her ideas and stimulate her imagination. From these images she develops her work through a process of trial and error, often as small studies before approaching full scale. Tony mulls over a range of possibilities in his mind before approaching paper or canvas. His resources are whatever filters through his experience, memory, and desire that he is able to articulate. From these possibilities he develops his ideas right on the final surface.

We admire each other's different abilities. After more than thirty years of teaching art full time at a community college, Judith has finely honed her skills as a nurturer of incipient ideas. Tony's long experience with Art Institute graduate students has developed his analytical and critical ability. We bestow on each other, by turns, encouragement and criticism. Depending on the timing and the tone, comments may or may not be welcome.

Are we jealous of each other? Glimmers here and there, but nothing abiding. It's too embarrassing to express, so it goes underground to emerge not quite appropriately in some other context as a little fuel for maintaining the heat.

We feel that we are lucky to have found each other. We feed, stimulate, exasperate, and shape each other such that we continue to grow together. The life we share continues to expand and evolve. It affords us happiness and fulfillment.

ROBERT The first (and often unconscious) acts when we look at the world: framing and focusing. As artists, of course, we know this, and yet our consciousness concerning the question remains intermittent.

MARY *Framing and cropping, selective focus. Isolate subject. Try to follow naturally with camera (or keep camera totally still). Video will reveal all the flaws—yours and theirs. Retain dignity (theirs and yours). Take responsibility for everything inside the frame—that's integrity.*

To what discrete portion of the infinitely huge reality (in which we are spatially, culturally, temporally immersed) do we devote our attention?

Communication among the parts creates the possibility of unanticipated new wholes. Inadvertently, I become part of the picture I record. Someone off-camera is communicating with John in rudimentary sign language. He has John's total attention. For a moment, looking through the viewfinder, I am flustered by this. How do I account for it? The answer is, I don't have to. This is not journalism. This is not reality.

Why this and not that?
What accounts for our coming back time and again to some subject or some essential configuration that, as artists, we find continually new and sometimes even shocking, as though seeing or thinking something for the first time?

The idée fixe. An obsessive subject that recurs again and again. All my work is basically about one or two things. I keep trying to get it right.

The matter of how these choices are made becomes intriguing on another level when we ask about the relationship between artists who live and work in tandem and how this might make for an overlay of patterns, through interacting, moving out in separate directions, sometimes converging.

Do we choose our subjects or do they choose us?

Mary captures and transforms an astonishing narrative of events half a world away. I discover, with some amazement, a rather ordinary visual event near to home on a gray March day.

My work proposes a view of the world as a structure of more or less equal or parallel systems, each with its own intrinsic technology, in which communication is a personalized, evolving system of signs, equally obscure and available to all.

MARY LUCIER
ROBERT BERLIND

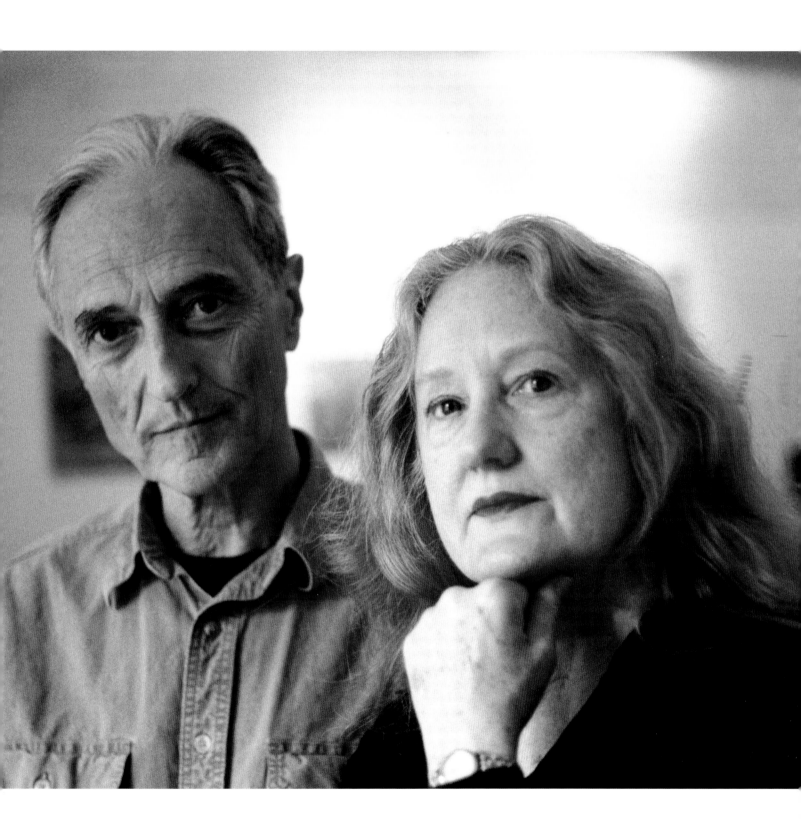

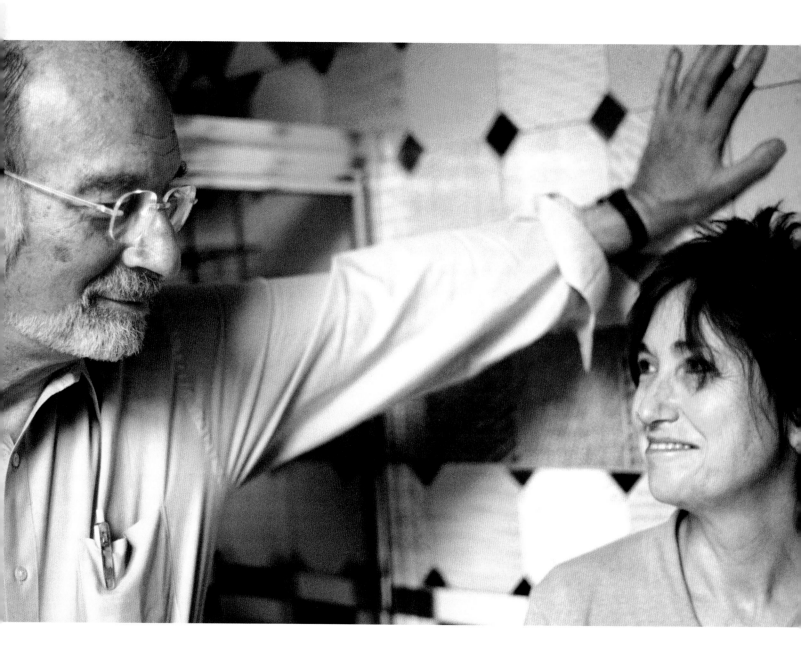

JOYCE KOZLOFF
MAX KOZLOFF

Max is much more relaxed about making art than I am. His career is writing. Although he loves to paint and take photographs—and those activities give him a great deal of pleasure—he is not driven either by internal pressures or external deadlines. This is a great luxury. I am the opposite. There never are enough hours in a day; the studio has a constant pull on me. Somehow, my work is always several paces ahead of where I am, so I'm always running to catch up with myself.

I enjoy Max's paintings and photographs, which are more about the color and texture of life than about "ideas." He has sometimes been quite critical of my work. It's hard to take at first, but it does prepare me for the real world. No one out there is as tough as he is at home. Max is smart and has a good eye. Often he questions my work when it's new and then comes around later; in the end, I have to trust myself. He almost never asks for my feedback on his writing, because he's supremely confident in that area. When he asks for my opinion about his pictures, he's much more shy and diffident. But I am not very critical—it's not my nature.

I'm affected very much by outside events and stimuli, travel, and politics. We have a rich daily discourse, which I value. But I also have a lively exchange with other friends as well. I would not want to restrict myself to just one dialectical relationship!

Private responsibilities are daily negotiations. Now that we don't have young children or day jobs, it's not such an issue.

What does it mean to be a part of an artist-couple? I wouldn't want to be married to a banker or dentist. What would we talk about?

February 26, 2006
Sedona, AZ

Dear Joyce,

 Lisa and I just finished a long hike in Sedona, Arizona. This area is
considered a vortex site because of its confluence of positive energies.
A strange thing has happened to us in this vortex.
 It started innocently enough. I'm here staying for a week at a
utopian community called Arcosanti as a guest of the Scottsdale Museum
of Contemporary Art. Lisa has joined me for the weekend. On average
I'd say we get one weekend a year away from the kids. It's something
we normally really look forward to.
 So this morning we decided to hike on a trail called The Devil's
Sink. Lisa usually wants a challenge. I hate exerting myself. It keeps
me from reaching that numb-mind state that is the seat of my creativ-
ity. At first there were a lot of other hikers, and even a herd of
annoying pink jeeps escorting tourists lazier than I. Eventually, civi-
lization fell away, and we found ourselves following the path of a dry
creek bed and talking about nothing new: about our kids, about our
life together, our relationships.
 But Lisa decided that this wasn't enough. She asked me if I remem-
bered the couples show that we were asked to participate in. I've
been making these photographs lately, mostly in the landscape. They are
panoramas, really, but collaged from snapshots, sort of like Hockney, but
bigger. They're pretty good, really. I kept asking Lisa if she thought
this spot or that spot might make a good photograph. She asked me
if I remembered that we had to write something for the Couples
catalogue. We started talking about whether it's interesting to try
to make art out of what is essentially a tourist's snapshot. But there
was kind of an edge in Lisa's tone that I recognized, vaguely, but it
seemed, well, more apparent than it ever had before. All of a sudden
our discussion turned into a fight. And we never fight. I can't even
remember the last time we had an argument. But in the midst of this
picturesque arroyo, in one horrific instant we had devolved from the
happy loving couple into a spitting, hateful monster. Things were said.
As it turns out, Lisa's heartfelt interest in my work the past twenty
years was an utter fake. To what end, I have no idea, because this is
an awful mess. To tell you the truth, I never really cared for her
stuff either.
 Lisa caught an early plane back and I'm left here with my computer,
trying to pick up the pieces. I have no idea what's waiting for me
back in Brooklyn. Honestly, I don't know what to do. The sunset over
the mesa near where I'm staying is orange and vibrant purple. It's really
quite nice here.
 Just thought I'd keep you up to date.

Yours,
Byron

P.S. Do we still have to be in the show?

LISA SIGAL
BYRON KIM

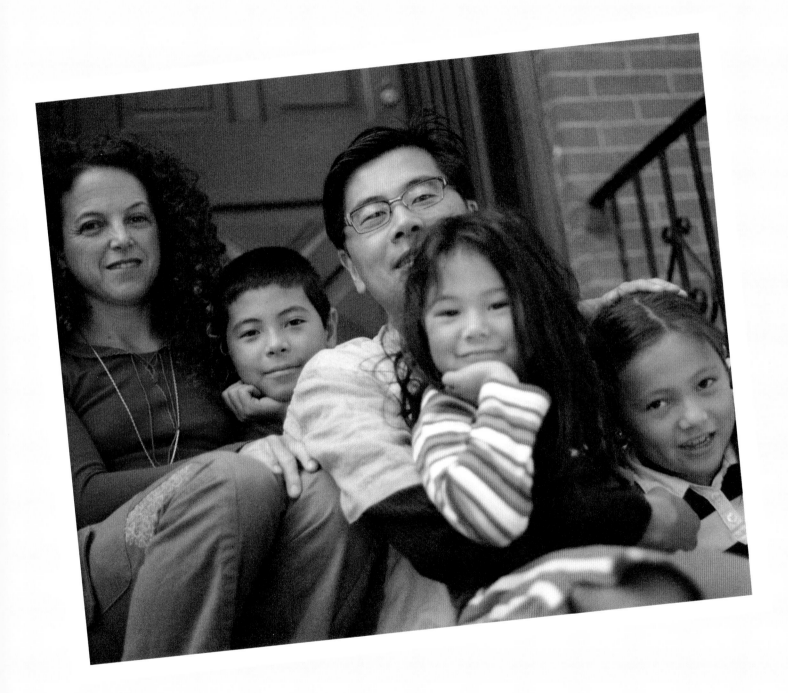

catalogue

Authors:

Joyce Henri Robinson JR

Micaela Amateau Amato MA

Sarah Holloran SH

Barbara Kutis BK

Christine Swisher CS

ARLENE BURKE-MORGAN Clarence Morgan

SHORTLY AFTER ARLENE BURKE-MORGAN completed her M.F.A. degree at East Carolina University in 1989, a number of her sculptural ceramic pieces were featured in a groundbreaking exhibition. *Next Generation: Southern Black Aesthetic*, organized by the Southeastern Center for Contemporary Art in Winston-Salem, brought together the work of trained and self-taught black artists residing in the South, and guest curator Lowery Sims selected three of Burke-Morgan's monolithic ceramics for inclusion alongside work by such artists as Beverly Buchanan, Martha Jackson-Jarvis, Winnie Owens-Hart, and Joyce Scott. Sims recognized the "spectre of African art" confronting many of the artists in the exhibition, noting that Burke-Morgan's mute totems appeared "to have come out of some primordial heap, some archaeological stash" like ancient deities or representatives of a "dormant race."[1]

In recent years Burke-Morgan has turned her attention to painting, and the understated earth tones of her clay work have given way to vibrant, declamatory color. A newfound, or perhaps rediscovered, spirituality played a part in this transformation, and since the early 1990s she has produced paintings, drawings, and prints that draw on the truths of her luminous faith.[2] Despite its noncommittal title, *Painting #2* reveals the "circles of light"—age-old ciphers of unity and the divine—that dominate much of her work. Burke-Morgan has suggested that the diagonal motifs cutting across the surface are emblematic of danger and are derived, somewhat unexpectedly, from the cautionary stripes found on highway safety barricades.[3] The woven paper used by the artist in this instance provides an underlying structural grid for her abstract geometries and gently evokes the stitched squares of a riotous quilt. Burke-Morgan disavows any references to the syncopated rhythms and bold coloration of the African American quilting tradition in this painting, although one might argue that the "spectre" of the ancestors remains embedded in her latest work.[4]

Burke-Morgan, who is based in Minneapolis, has recently shown her work in one-person exhibitions at the Phipps Center for the Arts in Hudson, Wisconsin, and the Minnetonka Center for the Arts. She has received awards from the McKnight Foundation, North Carolina Arts Council, and National Endowment for the Arts, and her work is represented in a number of private and public collections. In 2000, she co-curated an exhibition on the work of self-taught artist Clementine Hunter for the Frederick R. Weisman Art Museum at the University of Minnesota.

JR

1 Lowery S. Sims, "On Notions of the Decade, African-Americans and the Art World," *Next Generation: Southern Black Aesthetic* (Winston-Salem: SECCA, 1990), 9.

2 Burke-Morgan discusses her spiritual conversion in an artist statement in *North Carolina Arts Council Artist Fellowships 1992/1993* (Charlotte, N.C.: Mint Museum of Art, 1993), 6.

3 See the artist's biography provided on the Web site of the Littleton Collection at http://www.littletoncollection.com.

4 In writing about *Works of Love*, a work by the artist from the mid-1990s, Mason Riddle likens Burke-Morgan's rhythmic patterns to African textiles and "bold" American quilts. Riddle notes that the artist's mother crocheted, and "she, herself, began her academic training in textiles and later sewed for her own children." See "Arlene Burke-Morgan," in *McKnight Artists*, no. 6 (Minneapolis: MCAD/McKnight Foundation Fellowship for Visual Artists, 1996–1997), 4–5.

Painting #2, 2003
Acrylic on woven and stitched paper
29 ½ x 29 ½ inches
Photo courtesy the artist

Clarence Morgan Arlene Burke-Morgan

FOR THOSE FAMILIAR WITH Clarence Morgan's large-scale, coloristic paintings from the last nearly two decades, the recent diminutive works on paper might come as a surprise. In the late 1980s and well into the '90s, critics found much to praise in Morgan's exuberant, painterly abstractions, labeling his intensely biomorphic visual language "embryonic," "protozoic," "visceral," and "sexually charged."[1] Many of these earlier canvases carry with them wonderfully portentous titles—*Semiotic Manhunt*, *The Power of Influence*, *Phallocratic Gesture*—and their organic forms in the guise of cocoons, phalluses, and seed pods pulsate with the cyclical rhythm of the life force.

Morgan has remained open, as he terms it, to "organically abstract possibilities." For a 2004 show titled *Momentum and Stasis*, the artist produced a series of intricate, colorful paintings inspired by the shifting patterns of light and flora in the natural environment. Bringing together "common geometric shapes, patterns, and biomorphic configurations … using a somewhat random matrix," Morgan created intertwining latticeworks of color overlaid with delicate stenciled motifs in a visual conversation with nature's quixotic moods and motifs.[2] Produced the same year, the black-and-white works on paper, like *Cartesian Framework*, reveal a similar elegance and intricacy of mark making on an intimate scale even as the ponderous titles remain. In the graphite, acrylic, and ink drawings, globular black shapes—part molecule, part Rorschach blots—float serenely across a tangled and frenetic graphic web. Freehand drawing confronts stencil, intuition dialogues with the intellect, and chaos is held in check by an orderly (Cartesian) grid.

Clarence Morgan received his training as an artist in his hometown of Philadelphia, completing a four-year certificate-diploma at the Pennsylvania Academy of the Fine Arts in 1975 and an M.F.A. at the University of Pennsylvania three years later. Morgan began his teaching career at East Carolina University and, since 1992, has been on the faculty at the University of Minnesota, where he currently also serves as chair of the Department of Art. Recent solo exhibitions include the aforementioned *Clarence Morgan: Momentum and Stasis* at the Steinhardt Conservatory Gallery at the Brooklyn Botanic Gardens and *Clarence Morgan: Hybrid Archetype* at the Sarah Moody Gallery of Art at the University of Alabama, Tuscaloosa. Morgan has been the recipient of many grants and fellowships, and his work can be found in numerous collections, including the Minneapolis Institute of Art, Frederick R. Weisman Art Museum, Walker Art Center, and New York Public Library.

SH/JR

1 See, for example, Shaw Smith, "Clarence Morgan," *New Art Examiner* 16 (June 1989): 50–51; Jon Meyer, "Southern Arts Federation, National Endowment for the Arts, Regional Visual Arts Fellowships," *New Art Examiner* 17 (October 1989): suppl., n.p.; and Stephen Margulies, "Clarence Morgan," *New Art Examiner* 19 (June/Summer 1992): 43.
2 Artist statement, Brooklyn Botanic Garden press materials, http://www.bbg.org/vis2/gallery/clarencemorgan.html.

Cartesian Framework, 2004
Graphite, acrylic, and ink on paper
20 ⅛ x 14 ³⁄₁₆ inches
Photo courtesy Gallery Joe, Philadelphia

HELEN MIRANDA WILSON

HELEN MIRANDA WILSON's paintings are diminutive, intimate portraits of a moment in time. "The light, the intense cold, and the fugitive clouds," she has observed, "only happened once."[1] The reduced scale in which she works challenges the more traditional, expansive treatment of landscape, a departure evident in *Blue Sky with Fifteen Clouds*. Here, Wilson explores the nuances of light and color discovered only in direct, detailed observation of natural phenomena, creating a fictive miniature window through which viewers glimpse a corner of sky. Wilson's work strikes an "uncanny equilibrium between realist and decorative," critics have noted, especially her skyscapes "filled with creative abstractions that are at the same time perfectly convincing clouds."[2] That the artist is determined to represent a precise instant is evident in her method of dating her work. As Mario Naves said of Wilson's cloud paintings in 1998, "Each image is based in observation of the most nuanced sort— anyone who dates her paintings according to the month has a stake in how time and season change the quality of light."[3] Wilson's desire to capture a fleeting image is evident in her own observations about the pitfalls of painting over the course of several days: "… if I go back the next day for anything except structural details—like the contour of a hill—I blow it, because the light's always different. And *I'm* different."[4]

Wilson makes her home on Cape Cod, in the town of Wellfleet, where she finds endless sources of inspiration for her jewel-like panels. She attended both the Skowhegan School of Painting and Sculpture and New York Studio School. Recent exhibitions include solo shows at DC Moore Gallery and Jason McCoy Inc., in New York and Albert Merola Gallery in Provincetown, Massachusetts. Her work has appeared in numerous group shows, including *Landscapes Seen and Imagined* at the DeCordova Museum; *Intimate Purlieus: The Diminutive Landscape and Contemporary Art* at the Palmer Museum of Art; *The Figure: Another Side of Modernism* at the Newhouse Center for Contemporary Art in Staten Island; and *Beyond the Mountains: The Contemporary American Landscape* at the Newcomb Art Gallery at Tulane University. Wilson's paintings reside in the permanent collections of the Metropolitan Museum of Art, Jersey City Museum, DeCordova Museum and Sculpture Park, Hirshhorn Museum and Sculpture Garden, and Weatherspoon Art Museum at the University of North Carolina, Greensboro.

<div align="right">CS</div>

1 Artist statement for *Intimate Purlieus: The Diminutive Landscape and Contemporary Art*, Palmer Museum of Art, The Pennsylvania State University, March 16–August 8, 2004.
2 "Painting, An Update: Helen Miranda Wilson," *Women Artists News* 14 (Spring–Summer 1989): 11.
3 Mario Naves, "An Ongoing Viability," *The New Criterion* 16 (May 1998): 41.
4 As quoted in "Painting, An Update."

Blue Sky with Fifteen Clouds, started November 1996
Oil on panel
9 ¹⁵/₁₆ x 10 inches
Photo courtesy DC Moore Gallery, New York

TIMOTHY WOODMAN'S FACELESS FIGURES are set in public places, engaged in often mundane pursuits—running on treadmills, playing chess, marching in a brass band. The activity depicted is "instantly recognizable," according to Hilton Kramer, a "vividly realized glimpse of life that is elevated for the viewer into a moment of lyric revelation."[1] Familiar as these activities may be, however, the participating characters are strangers. Their backs are often turned, eyes shielded by hat brims, seemingly as isolated as the dwellers of Edward Hopper's alienating cityscapes. Hayden Herrera notes that Woodman employs a technique used by Hopper to convey solitude: While the latter might isolate a figure against a white clapboard wall, Woodman's figures, by their very nature, are frozen against the stark white wall of the gallery.[2] Alone in a crowd, the figures go about their business—forever captured in the anonymous act of living.

Although the protagonist of *Ian Snowboarding* may appear to be as anonymous as any in Woodman's oeuvre, the piece—as the title indicates—captures the acrobatic maneuvers of a particular boy, a sportive lad by the name of Ian. Ian is depicted in mid-plunge, his graceful movement arrested in space. The viewer perceives the slope and tilt of the mountain, but sees, on further inspection, that the achievement is pictorial rather than plastic. The artist's manipulation of the picture plane in terms of linear perspective is evidence of his mastery of three-dimensional draftsmanship, what Kramer calls an ability to "draw in space."[3] The inherent three-dimensionality of *Ian Snowboarding* casts it in sharp relief against the wall, increasing the sense of depth achieved through paint and causing Ian and the mountain to project into the viewer's space. Like most of Woodman's figures, Ian is close, yet distant; anonymous, yet familiar; a stranger, yet a fellow dweller, in the modern landscape.

Woodman began his formal art education at the Skowhegan School of Painting and Sculpture before moving on to the Rhode Island School of Design in 1971. He went on to earn a B.F.A. at Cornell University and an M.F.A. at Yale University in 1976. Solo exhibitions of his work have taken place recently at the Tibor de Nagy and Zabriskie galleries in New York, and he has completed public commissions for the Western Historic Trails Center in Council Bluffs, Iowa; Ribicoff Federal Building and Court House in Hartford, Connecticut; and W. K. Kellogg Foundation in Battle Creek, Michigan. Woodman's work can be found in permanent collections around the world, including the Metropolitan Museum of Art, Smithsonian American Art Museum, Hirshhorn Museum and Sculpture Garden, and National Gallery of Australia.

CS

1 Hilton Kramer, "America in Perspective," *Art & Antiques* 21 (June 1998): 84.
2 Hayden Herrera, *Timothy Woodman: Recent Sculpture* (New York: Tibor de Nagy Gallery, 1998), n.p.
3 As discussed in Kramer, 85.

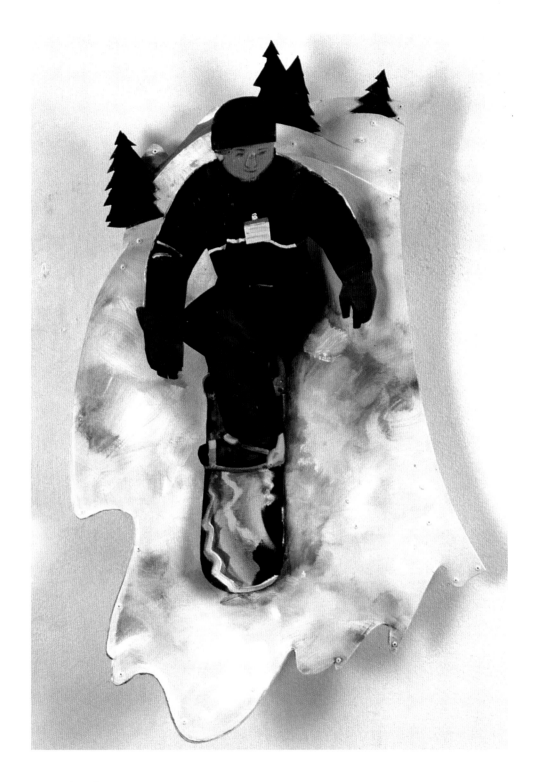

Ian Snowboarding, 2003
Aluminum and oil paint
24 ½ x 14 ¾ x 5 inches
Collection of Ian Rosenberg, New York
Photo courtesy Tibor de Nagy Gallery, New York

PATRICIA CRONIN DEBORAH KASS

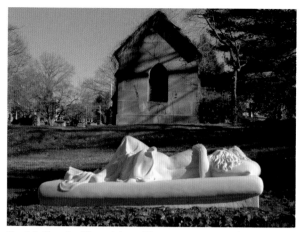

Patricia Cronin, *Memorial to a Marriage*, 2000–02. Carrara marble, over life-size, Woodlawn Cemetery, Bronx, New York. Photo courtesy the artist

PATRICIA CRONIN HAS COMMENTED that she is essentially a conceptual artist who uses a wide range of traditional forms—watercolor, landscape painting, equestrian statuary, mortuary monuments—to investigate "contemporary ideas."[1] For well over a decade, those conceptual ideas have been centered on charting an aesthetic as well as a public space for the queer body and female desire. In a series of erotic watercolors from the mid-1990s, Cronin explored the fleshy intimacies of lesbian sex from the vantage point of one of the participants, effectively subverting the dainty propriety long associated with watercolor and its amateur (often female) practitioners. From there Cronin turned her attention to the world of horses, dispassionately replicating in oil "pinup" portraits of equines that would set any teenage girl's heart aflutter. A series of diminutive bronze horses—cast from those much-collected plastic toy models—led the artist to consider the preponderance of public equestrian monuments celebrating the heroics of bellicose males. Cronin began searching New York City for public monuments featuring particular rather than allegorical women: She found Eleanor Roosevelt, Golda Meir, Joan of Arc, Alice in Wonderland, and Mother Goose.

In the body of work accompanying *Memorial to a Marriage*, arguably Cronin's magnum opus, these varied interests merge as the intimate relationship of two very particular women is made public and, literally, monumental. Cronin and her partner, Deborah Kass, embrace in "post-coital bliss" on a sepulcher that is very clearly the bed they share together as a couple. The bronze, cast in 2004, is a reduction of the over life-size marble sculpture that today wistfully adorns the couple's future burial plot in the venerable Woodlawn Cemetery in the Bronx. *Memorial* draws on disparate sources ranging from the embracing women in Gustave Courbet's painting *The Sleep* and the baroque excess of Gianlorenzo Bernini's drapery in *The Ecstasy of Saint Teresa* to the neoclassical figural style of Victorian mortuary sculpture. For Cronin, the piece is a memorial to

the legal state of marriage and conjugal rights that at this point in time are denied same-sex partners. "We have wills, health-care proxies, powers of attorney, and all of the legal forms one can have, but they all pertain to what happens if one of us should become incapacitated or die. It's not about our life together; it's about the end of it. So I thought, what I can't have in life, I will have forever in death."

Cronin received her B.F.A. from Rhode Island College in 1986 and her M.F.A. from Brooklyn College in 1988. She has been the recipient of two Pollock-Krasner Foundation grants and an award supporting *Memorial to a Marriage* from Grand Arts, Kansas City, and she has taught at the School of Visual Arts, Columbia, Yale University, and Brooklyn College. A retrospective of her work, *Patricia Cronin: The Domain of Perfect Affection, 1993–2003*, was organized and shown by the University of Buffalo Art Gallery in 2004. In 2006, she was awarded the "John Armstrong Chaloner/Jacob H. Lazarus-Metropolitan Museum of Art Rome Prize" by the American Academy in Rome for her project *Musings on Harriet Hosmer's Roman Life, Work, and Career.*

JR

1 Jan Garden Castro, "Making the Personal Monumental: A Conversation with Patricia Cronin," *Sculpture Magazine* 22 (January/February 2003): 45. Subsequent quotes from the artist are taken from this source.

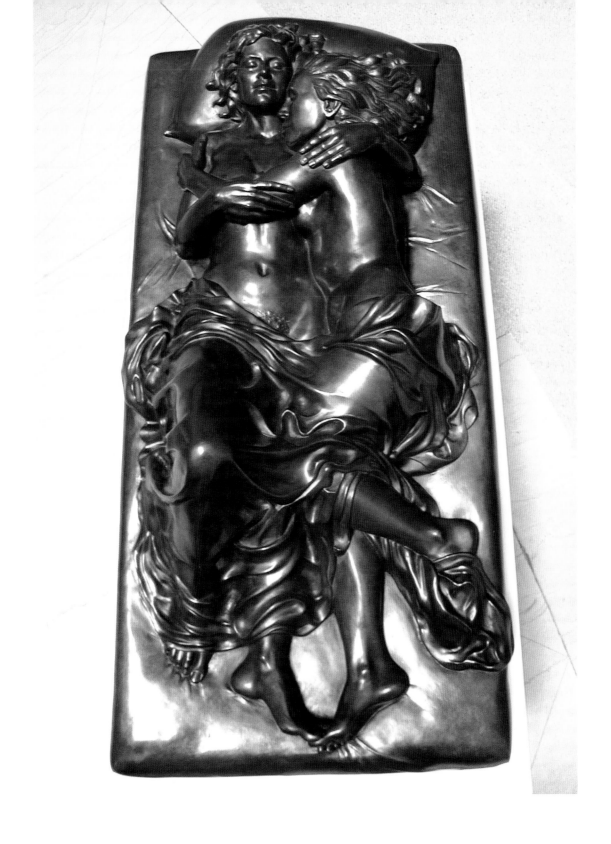

Memorial to a Marriage, modeled 2001–02, cast 2004
Bronze
17 x 27 x 53 inches
Photo copyright Adam Husted

DeBOrah Kass Patricia Cronin

SELF-PORTRAITURE HAS LONG BEEN an important aspect of Deborah Kass' work. "To represent one's self is, after all," she notes, "the artist's job."[1] As an art student in college in the early 1970s, Kass felt compelled to place herself in "the field of painting" and began incorporating her own image in works that were stylistically indebted to the pictorial gestures of a patriarchal modernist heritage. Operating under the assumption that one must know one's oppressor, Kass experimented with the masculine language of high modernism, implicating herself and her own concerns about sexual and ethnic identity as she questioned the sacrosanct status of the masterful male artist. In the late 1980s, Kass was blatantly appropriating stylistic elements and content from recent masters—Jackson Pollock, Frank Stella, Philip Guston—as well as from popular culture. By 1992, these disparate sources merged with the inauguration of the artist's Warhol Project.

Kass began her trenchant exploration and deconstruction of Andy Warhol, the grand master of Pop, by recasting his pantheon of media stars. Barbra Streisand replaced Jackie, Yentl (Barbra in drag) stood in for Elvis, and Gertrude Stein made an impressive appearance in the guise of Chairman Mao in the early years of the project. *Silver Deb*, a more recent work, continues this shifting of characters, and the artist herself assumes the role of the quintessential American starlet, Elizabeth Taylor. Kass mimics the silkscreen process, the exact scale, and the vivid coloration of Warhol's original (*Silver Liz*, 1963), although as Linda Nochlin has said of her work in general, the effectiveness of Kass' version is conveyed through the purposeful deviations from its source, namely the substitution of the artist's facial features for those of the well-known movie star.[2] The recasting of Liz as a Jewish lesbian artist complicates Warhol's "cool" WASP aesthetic and his seeming refusal to penetrate the surface of his sitters' public personas. "It's a big subject," the artist concedes, "representing me and my absence in representation."[3]

Kass received a B.F.A. in painting from Carnegie-Mellon University in 1974. Her work has been featured in many one-person and group shows dedicated to a wide range of themes, from gender and Jewish identity to self-portraiture, the legacy of Pop, and art and politics. Her work is represented in numerous private and public collections including the Solomon R. Guggenheim Museum, Jewish Museum, Museum of Modern Art, Whitney Museum of American Art, New Museum of Contemporary Art, and Museum of Fine Arts, Boston.

JR

1 As quoted in Mary Anne Staniszewski, "First Person Plural: The Paintings of Deborah Kass," in Michael Plante, ed., *Deborah Kass: The Warhol Project* (New Orleans: Newcomb Art Gallery, Tulane University, 1999), 23.
2 Linda Nochlin, "Deborah Kass: Portrait of the Artist as an Appropriator," in Plante, 10–11.
3 Deborah Kass, "A Conversation with Patricia Cronin," *M/E/A/N/I/N/G*, no. 14 (November 1992): 12; as quoted in Staniszewski, 23.

Silver Deb, 2000
Silkscreen and acrylic on canvas
40 x 40 inches
Photo courtesy the artist

ELEANOR ANTIN DAVID ANTIN

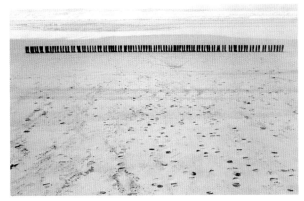

Eleanor Antin, *100 Boots Facing the Sea*, 1971. Photo courtesy Ronald Feldman Fine Arts, New York

"PERFORMANCE," Eleanor Antin notes, "is at the core of my work, as is theatre. I see the self as a player, an actor, an inventor on a stage, which is the world."[1] Although this statement was made more than a quarter of a century ago, the essence of the artist's comments remains germane to her work today. In two recent photographic series, *The Last Days of Pompeii* (2001) and *Roman Allegories* (2004), Antin has shifted roles from artist/performer to artist/director—a role familiar to her from her work as a filmmaker—and theatrical invention continues to be central to her enterprise. The more recent of the two series was inspired by a brief, evocative excerpt from the writings of the ancient orator Pliny the Younger: "That summer, in the first year of the reign of Titus, there appeared a small band of players who met with some success until they disappeared without trace, leaving behind one of their number." Composed of twelve large-scale, lushly orchestrated photographs, *Roman Allegories* charts the wanderings of the doomed troupe, their progeny familiar to us in the stock characters of the commedia dell'arte. As in the Pompeii series, the setting for these allegorical tableaux vivants is a thinly veiled southern California, home to the artist and a fitting backdrop for the perambulations of two-bit players whose histrionics do little to deflect their destiny.

Going Home is the denouement of the series, a sparse panorama punctuated by toga-clad actors making their way (save for the giddy child left behind) to a primordial watery grave. Although many of the photographs in the series reveal a sense of baroque excess reminiscent of French Salon painting, this piece calls to mind the matte surfaces, blonde tonalities, and decentralized compositions of the great nineteenth-century muralist Pierre Puvis de Chavannes. For those familiar with Antin's early work, the standing figures in *Going Home* also conjure up the artist's now-classic *100 Boots Facing the Sea* (1971), in which a cavalcade of footwear faces the sea with a similar sense of rectitude and fatalism.[2] The black umbrellas offer a surreal, Magrittean touch and, like other anachronistic elements in the photograph, invite us perhaps to muse on the decadence of our own time, centuries after Pliny. If we can trust the ancient writer, these thespians set off on their journey during the summer in which Mt. Vesuvius so famously erupted, resulting in the annihilation of Pompeii and the seaside town of Herculaneum and the disappearance "without trace" of innumerable lives.

Antin has been an important voice in the contemporary art world since the mid-1960s. As a conceptual artist, she has worked in a wide range of media—photography, film, video, performance, and installation—exploring her own identity through a multitude of fictive personas. Her work is represented in numerous public collections across the United States, and in 1999, the Los Angeles County Museum of Art organized a major retrospective of her work. Her exhibition of *The Last Days of Pompeii* at the Ronald Feldman Gallery, New York, won the AICA (International Association of Art Critics) First Place Award for Best Show by a Mid-Career Artist in 2001. In 2006, she received the National Lifetime Achievement Award from the Women's Caucus for Art of the College Art Association.

JR

1 As quoted in Dinah Portner, "Interview with Eleanor Antin," *Journal: Southern California Art Magazine*, no. 26 (February–March 1980): 34.
2 Between 1971 and 1973, Antin produced and distributed via mail a large group of picture postcards featuring fifty pairs of rubber boots in a host of situations: hiking through fields, going to the bank, trespassing on private property, boarding a ship, entering a museum, and even riding a rollercoaster. *100 Boots* was published in book form by Running Press Book Publishers in 1999.

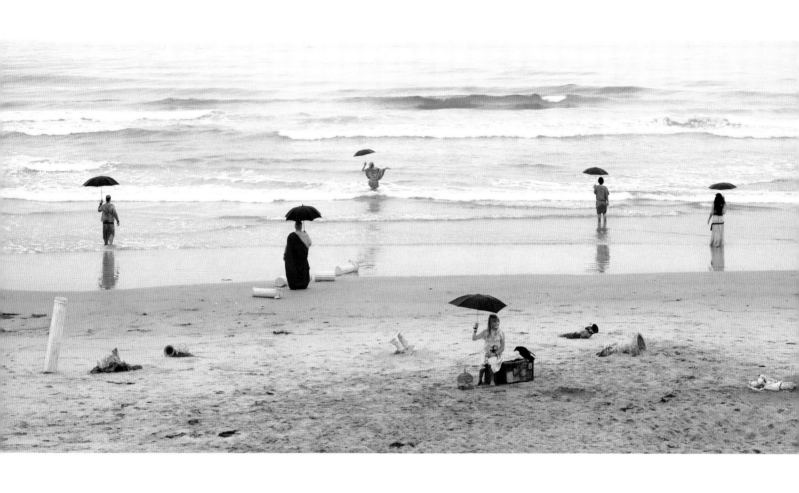

Going Home, from *Roman Allegories,* 2004
Chromogenic print
48 ½ x 102 ¾ inches
Photo courtesy Ronald Feldman Fine Arts, New York

DAVID ANTIN Eleanor Antin

IT'S NOT SO MUCH that David Antin's "talk poems" are spontaneous or off-the-cuff. Unscripted, certainly, but more akin to improvisation—composing on the fly—like jazz. He points to Coltrane, Parker, even Monk. But Antin is leery of the word "improvisation." As he says, he's "come to distrust what most people think it means the idea of starting from a blank slate nobody starts from a blank slate … each in his different way going over a considered ground that became a new ground as they considered it again."[1] But improvisation it is. Like Coltrane, "constantly working over scales and examining other musical maneuvers to keep his hands on a lot of things that he could do,"[2] Antin does feel that he improvises with language, which he views as a "well-formed grammar"—a structure like the chord progressions and inventions that jazz musicians study, practice, and experiment with, finally taking the stage with all but predetermined notes on a page. He views the process as one of thinking out loud: "… language is a reservoir of ways of thinking, because what I am really interested in, at least as much as language, is thinking: not thought but thinking. And the closest I can get to thinking is talking."

Antin's talk-poetry is presented as lived experience, a regurgitation of memories not previously committed to paper but nevertheless transformed into language before an audience. Long, involving, sometimes-exasperating accounts are balanced with short and often mystifying images. Antin involves his audience in his process of recall, working through his memories, evoking with great detail those that appear most vivid and glossing over those that slip away. Each memory provokes another, creating a string of uttered observances that seem part stand-up comedy, part lecture, part storytelling, part poetry.[3] Antin's art is a verbal exposition of the thinking process and is most evident in *How Wide is the Frame?*, where he leads the listener (and the reader) on a journey through museum politics and car accidents and electronic music and the mathematical inclinations of his father-in-law to a final disturbing encounter with a stranger. The course of

contemplation and the possibilities and associations that surface when the proverbial ball is set to rolling are the essence of Antin's production. And he generously invites the audience along for the ride.

Antin is purported to have said "suppositories" before the age of 2 and to have published his first piece of prose at the ripe old age of 9.[4] He has served as educational curator for the Institute of Contemporary Art in Boston and director of the University Art Gallery at the University of California, San Diego, and since 1972 has taught in the art department at UCSD. Antin has published extensively, including *A Conversation with David Antin* (with Charles Bernstein, 2001), and, most recently, *i never knew what time it was* (2005). His present work takes his particular style of storytelling into the realm of cinema, leading him to complete the third in a projected series of sixteen films: a film noir, a science fiction film, and a road movie, each ninety seconds in length or less. The entire series will be shown in a performance that runs no more than thirty minutes.[5]

CS

1 David Antin, *i never knew what time it was* (Berkeley: University of California Press, 2005), ix–x.
2 As quoted in Hazel Smith, "Talking and Thinking: David Antin in Conversation with Hazel Smith and Roger Dean," *Postmodern Culture* 3 (May 1993): 2. Unless otherwise noted, quotes from the artist are taken from this source.
3 Smith and Dean, 1.
4 David Antin, *Autobiography* (New York: Something Else Press, 1967), 15.
5 "Biography," University of California, San Diego, Department of Visual Arts Faculty, http://visarts.ucsd.edu.

so once again its a matter of the frame of how to frame an
event it seems easy as simple as the fall of a glass of water a
glass of water falls to the floor and smashes it slips through my
hands and smashes

 but its not a glass of water its a whiskey sour
you ask for a whiskey sour and the bartender hands it to you but the
condensation on the outside of the glass produced by the ice makes it
slippery so it slides through your hands and falls to the floor where
it smashes and there you are the ice the pieces of glass the drink
on the floor and youre slightly embarrassed by all this as you wait
for the bartender to get you another drink

 we had an event you asked for a drink it was handed to you
it slipped through your hand and smashed on the floor by why are
you embarrassed why did it slip from your hand

 it slipped through my hand because just as he handed it to me i
looked up and saw someone over there implausibly at this party
in this fifth avenue apartment house i saw a woman i knew and there
was no way she could have been there it was an old girlfriend and
i was so surprised at seeing her that i failed to take hold of the glass
 which slipped out of my hand and smashed and i looked down at
the floor and saw the glass and the whiskey on the floor and i looked
 up to see my girlfriend who i wanted to go say hello to and she
had suddenly turned away and was headed for the door shed been
 standing there before in a crowd of people and then she was out the
 apartment door

 i left my drink on the floor and started walking after her following
her out the door figuring before she goes away i should exchange hellos
 with her i get out the door and shes already in the elevator going
up to another floor i push the button so the elevator comes back
 down and i go up i figured by the time i got out i would have lost
her but actually shes way down the hall turning into another
 apartment i see what apartment she enters and follow her down the
hall i figure ive gone this far i may as well say hello to her i
knock on the door and a woman comes and opens the door and shes
wearing the same dress but its not my girlfriend at all

 its a eurasian woman a beautiful eurasian woman who doesnt
look the least like my girlfriend

How Wide is the Frame?
Excerpt from a published text version
of an improvised performance at the
Getty Research Institute, Los Angeles,
April 26, 2002, from David Antin,
i never knew what time it was (Los
Angeles: University of California
Press, 2005), 147–48.

nene Humphrey Benny Andrews

THE TITLE OF NENE HUMPHREY's recent body of work, "Small Worlds," resonates with meaning in the globally interconnected nexus in which most of us find ourselves living today. In 2002, Humphrey made the first of two visits to Guizhou, a remote province in southwestern China, where she immersed herself in the distinctive weaving and sewing culture of the rural Miao people. Lacking a written language, the Miao rely on exquisitely handcrafted textiles—loomed and stitched primarily by girls and women—to convey oral knowledge and history and to honor their ancestors. Having herself been raised in a relatively isolated small town in Wisconsin by a mother who was a needle worker, Humphrey was fascinated by the intricate craftsmanship and brilliant coloration of the textiles produced in the remote Miao village. Her sculptural installations soon betrayed evidence of this experience as she began weaving embroidery thread, ribbons of silk, felted wool, and cotton into the fabric of her work.[1]

Produced in the wake of her travels across the globe, *Pierced Red* draws on the concepts of "Small Worlds Theory" (also known as Six Degrees of Separation), a contemporary branch of sociology that posits that all five billion human beings across this vast planet are indeed connected in some fashion. According to the artist, the diminutive sculpture was loosely modeled on the form of a human head before being divided into two parts. The uneven halves are both seductive and menacing; corsage pins sensually wrapped in rich red silk pierce the outer felt layer, exposing an inner latticework of ominous metal teeth. The voluptuous bundles of red fabric, like so much of Humphrey's work, invite a tactile response, one that is soon repelled by the vortex-like mesh of pins at the work's core. The artist enjoys such dichotomies and, drawing on another body metaphor, likens the piece to "the layer of skin that encases us … both amazingly strong, and yet so vulnerable and permeable."[2]

For curator Agnes Gund, who recently included Humphrey's work in a group show at P.S. 1 in New York, the artist's focus on red resonates "in terms of hand, pin, needle, and blood—how much women have to use their hands, and mar them."[3] The blood-red buds adorning *Pierced Red*'s outer skin also call to mind the teeming, subcutaneous cellular structure that all humans share—those "small worlds" that defy the socio-political boundaries of race, gender, ethnicity, and geography.

Humphrey has been the recipient of grants and fellowships from the MacDowell Colony, Rockefeller Foundation, National Endowment for the Arts, Asian Cultural Council, and Anonymous Was a Woman Foundation. She has had numerous solo exhibitions, including shows at the Islip Art Museum, Savannah College of Art and Design, Mississippi Museum of Art, Ogden Museum of Southern Art, and Katonah Museum of Art.

JR

1 See Nancy Princenthal, "Nene Humphrey: Weaving Geographies," in *Nene Humphrey: Weaving Geographies* (Savannah: Savannah College of Art and Design, 2004).
2 E-mail to author, January 11, 2006.
3 As quoted in Patricia Rosoff, "Nene Humphrey: Carnal Knowledge," *Sculpture* 23 (December 2004): 18.

Pierced Red, 2003
Corsage pins, felt, and silk
9 x 8 x 9 inches
Collection of Barbara and Ira Sahlman, New York
Photo courtesy the artist

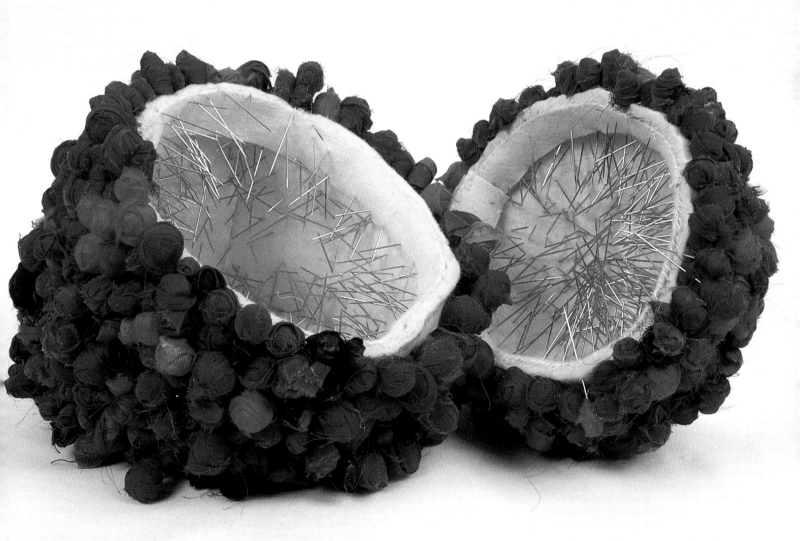

benny andrews Nene Humphrey

BENNY ANDREWS UNDERSTANDS WELL the role mass migrations have played in the history of America. As a descendant of the African diaspora, Andrews was raised in the rural South and spent more time working in cotton fields than attending school as a young boy. After a stint in the Air Force during the Korean conflict, Andrews pursued study in art at the Art Institute of Chicago before ultimately settling in New York in the late 1950s. This northward trek was a familiar journey for many African Americans in the early decades of the twentieth century as the lure of better jobs and educational opportunities drew them away from the southern homestead. "I knew ... that New York City was the place I'd always set out to come to," Andrews has commented, "just like Georgia had always been the place I'd set out to leave. All the places in between were only that, in between Georgia and New York."[1]

Andrews' latest body of work, *The Migrant Series*, is an extensive project that once completed will chart the westward migration of "Dust bowlers" in the 1930s, the demographic shift of black Americans to the North, and the forced removal of Native Americans via the "Trail of Tears." *New Home* depicts a displaced farm family of "Okies," who like thousands of others were forced to flee the drought-ridden Plains in the Depression era in search of more bountiful land further west. Inspired by the writings of John Steinbeck, whose novel *The Grapes of Wrath* famously narrated the often-bleak circumstances of one family's trek from Oklahoma to the Pacific West, Andrews examines the transience of the migratory journey. The family stands before a makeshift home, likely one of the "ditchbank" camps that migrants erected alongside irrigation ditches found on farms in the foreign, seasonable land of California. Andrews brilliantly employs collaged elements to add a visceral, textural punch to the painting's dramatic impact. Twine- and burlap-wrapped packages hang from the beleaguered jalopy porting the family's worldly possessions; burlap, too, frames the opening of their new abode, creating an uninviting transition into a new life. Critics have noted that Andrews' use of collage has little to do with formal experimentation but is more about reinforcing the realism of his narrative paintings. "I started working in collage because I found ... I didn't want to lose my sense of rawness," Andrews notes. "Where I am from, the people are very austere. We have big hands. We have ruddy faces. We wear rough fabrics. We actually used the burlap bagging sacks that seed came in to make our shirts. These are my textures."[2]

In addition to a long career punctuated by numerous one-person and group exhibitions, Andrews served as director of the Visual Arts Program at the National Endowment for the Arts from 1982 to 1984. His work is represented in the permanent collections of most major American museums, including the Metropolitan Museum of Art, Museum of Modern Art, High Museum of Art, Art Institute of Chicago, and Hirshhorn Museum and Sculpture Garden.

JR

1 As quoted in J. Richard Gruber, *American Icons: From Madison to Manhattan, the Art of Benny Andrews, 1948–1997* (Augusta, Ga.: Morris Museum of Art, 1997), frontispiece.
2 As quoted in Judd Tully, "A Collage of Painterly Roots," in *Folk: The Art of Benny and George Andrews* (Memphis: Memphis Brooks Museum of Art, 1990), 28.

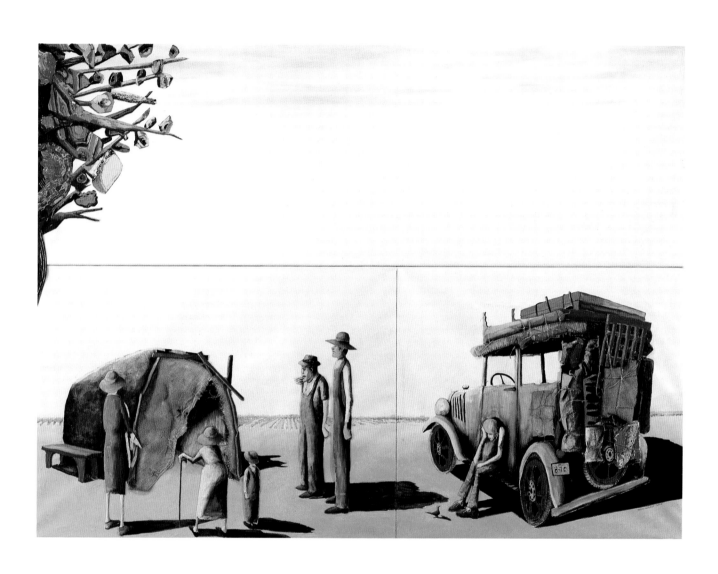

New Home, from *The Migrant Series,* 2004
Oil and collage on canvas
66 x 90 inches
Photo courtesy ACA Galleries, New York

HELEN MARDEN Brice Marden

HELEN MARDEN'S PAINTINGS and works on paper court the contradictions located in the interstices between abstraction and nature. While her linear forms move from translucent, ephemeral web- or water-like tracings to dissonant, frenzied gestures, Marden also collides the cultural artifact of "neon"-colored light with phosphorescent hues of insects found in nature. Her paintings gesture into consciousness the tentacles of jellyfish and the delicate appendages of sea anemone and other marine life. Shifting between the restless, agitated webs of her paintings and the transparent delicacy of her works on paper, Marden's method is clearly rooted philosophically in an Eastern rather than a Western sensibility. Her intensely hued, dry powdered pigments recall the textures and richness of mounds of curry, cayenne, and cumin, just as her use of high gloss recalls jellied and honeyed sweets of the subcontinent. Given the larger context of her sensibility—she has lived and worked extensively in India, Sri Lanka, and Thailand—it is easy to see how her work is infused simultaneously with the highly charged eroticism and the meditative calm of Indian and tantric miniatures.

In *A Cascade for Gauguin*, Marden pays homage to Paul Gauguin's migration from France to Tahiti, his disdain for bourgeois institutions, and the sensuous abandon and the spontaneity with which he engaged life. Marden is particularly drawn to the infamous nineteenth-century French artist's painting *Hina Tefatou (The Moon and the Earth)*, a canvas painted in 1893 and owned by the Museum of Modern Art, in which a nubile woman leans with abandon toward a waterfall, offering, perhaps, a gift of her primal self to the expatriate artist. Creating her own vibrant acrylic cascade, Marden delights in the fatuous imperiousness of the initial "disdain for Gauguin's work as having too much color ... clearly their motivations were suspicious!"[1] Marden ponders the cultural binaries that continue to define us—East and West, North and South, civilization and nature—having had her own "Eastern" sense of color on occasion misread as "garish." Likely the artist would concur with Gauguin, who long before her said, "I wish to establish the right to dare anything."[2]

Marden has shown her work internationally and was included in the 1995 Whitney Biennial.

MA

1 Phone conversation with the artist, May 16, 2006.
2 As quoted in R. B. Kitaj, "First Diasporist Manifesto," in Nicholas Mirzoeff, ed., *Diaspora and Visual Culture: Representing Africans and Jews* (London and New York: Routledge, 2000), 36.

A Cascade for Gauguin, 2005–06
Acrylic and dry pigment on canvas
100 x 34 7/8 inches
Photo courtesy the artist

Brice Marden Helen Marden

UT PICTURA POESIS. As is painting, so is poetry. Horace's famous simile, derived from his *Ars Poetica*, is an ideological keystone of Renaissance and neoclassical humanism and aesthetic theory. Embedded in the dictum are notions that the highest form of painting is that which is imitative (of nature), literary, and engaged with the noblest of human actions. Referencing the Horatian analogy may seem out of place in a discussion of the work of Brice Marden, who, for two decades beginning in the mid-1960s, was the "anointed prince of the flat monochrome canvas," to borrow Stephen Westfall's apt phrasing.[1] Modernism, with its disdain for narrative and championing of the primacy of painting's inherent planarity, is arguably the anti-*ut pictura poesis*.[2] Yet, the ancient notion that "painting is mute poetry"—with an Eastern twist—played a critical role in drawing Marden out of a self-described professional "mid-life crisis" in the early 1980s, enabling him to embark in a new direction and resulting in a sumptuous body of densely allusive abstract work.

Marden's interest in Asian poetry and painting was piqued by an exhibition of Japanese calligraphy in New York in late 1984; an ensuing and extended trip with his family to Southeast Asia and India furthered his engagement with Eastern culture. Although drawing had long been critical to Marden's practice, a graceful and emphatic linearity soon surfaced in the artist's painting, inspired both by the schematic glyphs of Chinese calligraphy (which gave rise to the Japanese tradition) and the intricate grid-like patterns of volute seashells collected in Thailand. The artist began avidly reading Chinese poetry, particularly the work of the eighth-century Tang poet Tu Fu, but found himself as intrigued by the ideographic elegance of the original calligraphy as by its translated content.

In *Diagramed Couplet #1*, Marden translates the vertically aligned characters of the Chinese couplet form into a painterly, calligraphic "cascade of bulbous glyphs," delineating a shallow, yet volumetric space through the tonal variations and overlap of his gestural latticework.[3] According to early Chinese aesthetes, two of the guiding principles of Chinese painting and calligraphy are "bone/structure" and "rhythmic vitality," principles that Marden clearly embraces and that indicate, too, his coming to terms with the profoundly influential master of labyrinthine skeins of paint, Jackson Pollock.[4] Critics have noted the anthropomorphic nature of Marden's upright, slightly larger-than-life scaffolds in this piece and in related work, likening them to Willem de Kooning's voluptuous women and to "'couples' linked protectively to one another, moving, dancing through space . . ."[5] Such associations aside, *Diagramed Couplet #1* beautifully captures the elegance and limned subtleties of Chinese brush-and-ink painting and calligraphy. As Klaus Kertess has noted, "writing becomes drawing, drawing becomes painting."[6] And, we might add, painting becomes poetry.

The *Diagramed Couplet* pieces preceded an important body of paintings and drawings titled *Cold Mountain* (from the hermetic Chinese poet Han Shan), which were shown as a group at the Dia Center for the Arts, Walker Art Center, Menil Collection, Museo Nacional Reina Sofía in Madrid, and Städtisches Kunstmuseum in Bonn between 1991 and 1993. A major retrospective of Marden's work will open at the Museum of Modern Art in late October 2006.

JR

1 Stephen Westfall, "Marden's Web," *Art in America* 80 (March 1992): 96.
2 Jan Baetens, "Modernism's '*ut pictura poesis*,'" *Image and Narrative: Online Magazine of the Visual Narrative* (May 2004).
3 Klaus Kertess, "Plane Image: The Painting and Drawing of Brice Marden," in *Brice Marden: Paintings and Drawings* (New York: Harry N. Abrams, 1992), 46.
4 Brenda Richardson, "The Way to Cold Mountain," in *Brice Marden—Cold Mountain* (Houston: Menil Foundation, 1992), 48. See Jeanne Siegel, "Brice Marden's Rhetoric," in *Painting after Pollock: Structures of Influence* (Amsterdam: G&B Arts, 1999), 88–99.
5 Kertess, 47, and Richardson, 57.
6 Kertess, 47.

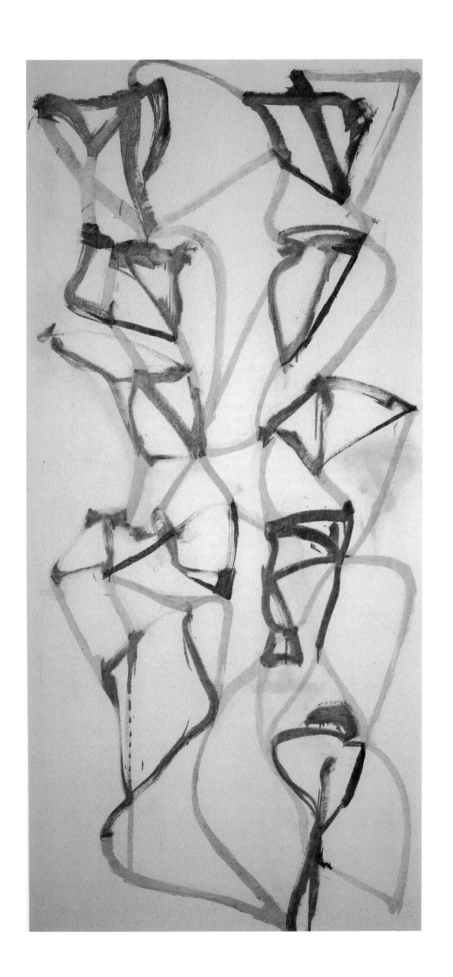

Diagramed Couplet #1, 1988–89
Oil on linen
84 x 40 inches
Photo courtesy the artist

suzanne Anker Frank GILLETTE

SUZANNE ANKER, WHO HAS long been interested in the intersection of art and science, recently posed a rather unusual question: "What happens when you can pick up a Rorschach test in your hand?"[1] While this might be a query that few of us have considered, we do share with Anker the basic human compulsion to find natural order amidst chaos or—put in more mundane terms—to find faces in the clouds. Hermann Rorschach well understood this most basic impulse (technically known as *pareidolia*) and, as most graduates of PSYCH 101 can tell you, developed a clinical method of projective psychological testing grounded on the principle of free association. Although their effectiveness as psychodiagnostic tools have been greatly debated, Rorschach's inkblots—abstract, amorphous, ambiguous—continue to intrigue us and speak to our desire to understand the inner workings of the mind, especially as we attempt to make sense of the inchoate barrage of stimuli we call life.

In her recent series of sculptures inspired by Rorschach's method, Anker has succeeded in giving tactile form to the Swiss psychiatrist's flat, rather lifeless stains using Rapid Prototyping, a relatively new technology whereby electronic information is translated into a three-dimensional physical model using plaster and resin. "Looking in 3-D, one begins to assess new meanings: bones, sea creatures, body parts," Anker has noted. "These are surrogates for the imagination itself.... The mind essentially has been embodied." Anker's assignation of meaningful titles to her sculptural inkblots probably reveals less about the secret recesses of her psyche than about her methods as an artist. Labeled a "scavenger" by at least one commentator, the artist first began casting both natural and manmade objects into other forms—first paper, then bronze—in the late 1980s, taking the familiar and transforming it into something unknown.[2] Mining a new field—clinical psychology—Anker reverses this process in the Rorschach series, translating a perplexing unknown into (a somewhat) familiar form: bear, crab, wolf.

Anker has stated that she is fascinated by "transformation and reincarnation," whether in the foundry, the laboratory, or, apparently, in the shrink's office.[3] The Rorschach pieces further her desire to explore and find meaning within nature's intricate patterns—chromosomes, MRI brain scans, inkblots—an age-old instinct in an increasingly complex world.

Anker's work has been shown in solo and group exhibitions around the world. An active writer and theoretician, she has published articles in *Art Journal*, *Teme Celeste*, *Leonardo*, and *M/E/A/N/I/N/G*, and she recently co-authored *The Molecular Gaze: Art in the Genetic Age* (2004) with sociologist Dorothy Nelkin. Anker has curated exhibitions for the New York Academy of Sciences on several occasions, and organized *Gene Culture: Molecular Metaphor in Contemporary Art* for Fordham University in 1994, and, more recently, *Neuroculture: Visual Art and the Brain*, which she co-curated with neuroscientist Giovanni Frazzetto for the Westport Arts Center. She has been on the faculty of the School of Visual Arts, New York, since 1993 and is currently chair of the fine arts department B.F.A. degree program.

JR

1 This and subsequent quotes from the artist can be found in "The Butterfly in the Brain," a summary of a talk by the artist as part of a symposium, "From Mirror Neurons to the Mona Lisa: Visual Art and the Brain," at the New York Academy of Sciences on November 5, 2005, at http://www.nyas.org. The original text reads, "What happens when you can pick up a psychology test in your hand?"

2 See, for instance, Linda L. Johnson, *A Dialogue with Nature: Nine Contemporary Sculptors* (Washington, D.C.: The Phillips Collection, 1992), 12, 15.

3 Artist statement in Marvin Heiferman and Carole Kismaric, *Paradise Now: Picturing the Genetic Revolution* (Saratoga Springs, N.Y.: The Tang Teaching Museum and Art Gallery at Skidmore College, 2001), 34.

Rorschach Series: Bear, Crab, and *Wolf,*
2004–2005
Rapid Prototype Sculpture
(plaster and resin)
Dimensions variable
Photo courtesy Universal Concepts Unlimited

Frank Gillette suzanne anker

"WHETHER IT IS OUR NEMESIS or our salvation," says Frank Gillette, "high technology is now an irrefutable fact of life while art—or more specifically image and object making—is the most ancient and continuous and eloquent form of human communication and/or expression." For Gillette, the question of the hour remains, "how is this archaic behavioral impulse for images to be linked up and integrated with humanity's most recent technological effluvia?"[1] Although he articulated this query in written form in the mid-1990s, Gillette has been exploring the potential of new technologies as a tool for the artist/image maker for nearly four decades. A pioneering video artist and early theorist of the medium, Gillette was a founding member in 1969 of the video collective Raindance, an alternative group dedicated to "cultural R & D" (research and development).[2] That same year, *Wipe Cycle*, a groundbreaking multi-channel installation by Gillette and collaborator Ira Schneider, was included in the milestone exhibition *TV as a Creative Medium*, organized by the Howard Wise Gallery in New York. Gillette's experimentation with closed circuitry and time-delay loops was cutting edge for its time and situated him at the forefront of those innovative minds expanding the terrain of the visual artist through technology.[3]

Gillette has been experimenting with computer imaging since 1991, pushing that accepted artistic terrain even further in an age that increasingly is going digital. At first glance, *The Broken Code (for Luria)* appears to have no real world analogue. On closer inspection, however, fragments of words—mostly illegible and oddly unfamiliar—begin to emerge amidst the matrix of almost gestural black markings. The text is derived from a manuscript of Gregorian chant, a sacred script selected by the artist for purely optical, rather than spiritual, reasons.[4] The piece's multivalent title is triply resonant, referencing dysfunctional computer program code, the language of DNA, and, via its parenthetical aside, Kabbalistic theology. According to Jewish scholar Isaac Luria (1534–1572), the universe was created through a catastrophic "breaking of the

vessels," which led to the dispersal of divine light and archetypal values throughout the cosmos. Gillette confirms that he is interested in the intersection of "the genetic, the musical, and the philosophical," merging three sets of "coding experiences" into a visual composition of his own genesis that speaks as much of mysticism as mitosis.[5] Although *The Broken Code (for Luria)* is ultimately mediated electronically, the questions posed by this digitally manipulated image extend well beyond the technological and dwell quite comfortably within the ancient province of the artist-creator.

Gillette's video work has been shown in numerous solo and group exhibitions at prominent institutions around the world, among them the Whitney Museum of American Art, Corcoran Gallery of Art, Everson Museum of Art, Museum of Modern Art, Institute of Contemporary Art, Boston, Carnegie Museum of Art, San Francisco Museum of Modern Art, Neuer Berliner Kunstverein, and Kunsthalle Cologne. He is the author of *Between Paradigms* (1973) and *Of Another Nature* (1988) and has received fellowships and grants from the Rockefeller Foundation, Guggenheim Foundation, New York State Council on the Arts, National Endowment for the Arts, and American Academy in Rome.

JR

1 Frank Gillette, "Q&A," in Gail Rubini and Conrad Gleber, *The Future of the Book of the Future* (Tallahassee: Florida State University Museum of Fine Arts, 1994), 12.
2 "Raindance, Biography," Video Archive, Electronic Arts Intermix, http://www.eai.org.
3 See David A. Ross, "Frank Gillette: Development of Recent Works," in *Frank Gillette, Video: Process and Meta-Process* (Syracuse: Everson Museum of Art, 1973), 25–27.
4 This remark and subsequent comments about the piece are taken from a phone conversation with the artist on April 21, 2006.
5 Suzanne Anker and Dorothy Nelkin note that in *The Broken Code (for Luria)*, Gillette "turns a Gregorian chant into a dance of mitosis" in *The Molecular Gaze: Art in the Genetic Age* (Cold Spring Harbor, N.Y.: The Cold Spring Harbor Laboratory Press, 2004), 193.

The Broken Code (for Luria), 2003
Digital print mounted on aluminum
24 x 72 inches
Photo courtesy the artist

Laurie Simmons carroll Dunham

Bathroom from *The Instant Decorator* by Frances Joslin Gold
(New York: Clarkson N. Potter, Inc., 1976)

EXTREME HOME MAKEOVERS have become standard fare in today's society as a barrage of reality-based television programs lure middle-class viewers to dream of domestic bliss in updated interior spaces. Since 1976, Laurie Simmons has been photographing fictive domestic spaces, initially focusing on dollhouses and their unnerving, miniaturized inhabitants and furnishings. Simmons' recent body of work furthers this exploration, literally utilizing a home-decorating manual from the 1970s as a template. In 2001, Simmons was given a vintage copy of Frances Joslin Gold's *The Instant Decorator*, a do-it-yourself guide featuring acetate overlays of line-drawn rooms that enabled aspiring decorators (likely bored housewives) to try out a variety of fabric and wallpaper combinations. In the wake of 9/11, unable to access her Lower Manhattan studio for an extended period of time, Simmons retrieved the spiral-bound guide from a bookshelf and began accessorizing the generic domestic spaces, eventually adding "characters" to the vacant rooms. The resulting collages, which the artist then photographed, feature fabric swatches as well as images gleaned from fashion magazines, porn comics, and catalogues.[1]

Simmons acknowledges that her selection of decorative accoutrements is somewhat arbitrary, for as she notes, "the detritus around us is ultimately very random."[2] In *The Lavender Bathroom*, ersatz classicism mingles with Audubon prints, Arts and Crafts wallpaper, shag carpeting, and disarmingly large loofahs. Disjunctions in scale and medium—most obvious in the mix-and-match body of the blonde bombshell—add to the work's discomfiting allure as does the "neutral skin" of the slick photographic surface, so at odds with the tactile craftiness of collage. Despite these off-putting elements, which together offer a wry commentary on society's obsession with consumption and material comfort, the series resonates with nostalgia and personal memory. Simmons has written about the tastefully appointed home in which she grew up, overseen by a mother with an eye for color and a penchant for domestic decorum. "My favorite rooms were of

course the bathrooms, particularly the one in the master bedroom suite," Simmons writes. "It had classic four-by-four matte black tiles and an exquisite maroon sink. Rooms had color themes and were gender coded. Pinks and reds for girls; powder blue for a baby boy.... Rooms were kept freshly carpeted and curtained. Hallways were hung with fuzzy, flocked wallpapers."[3]

Simmons received her B.F.A. from the Tyler School of Art, Philadelphia, in 1971, two years before moving to New York, where she still works and resides. Her work is represented in most major American museums, including the Metropolitan Museum of Art, Museum of Modern Art, Corcoran Gallery of Art, Philadelphia Museum of Art, Whitney Museum of American Art, Walker Art Center, Baltimore Museum of Art, and International Center for Photography, New York. *Laurie Simmons: In and Around the House*, a survey of the artist's early black-and-white photographs from 1976 to 1978, was published in 2003.

JR

1 Linda Yablonsky, "Better, More Surreal Homes and Collages," *The New York Times*, February 15, 2004, sect. 2, 18.
2 As quoted in "The Antidecorator," Home Design, Part 2, *The New York Times Magazine*, April 13, 2003, 76–79.
3 Laurie Simmons, "In and Around the House," in *Laurie Simmons: In and Around the House, Photographs 1976–78* (New York: Carolina Nitsch Editions, 2003), 20–21.

The Instant Decorator (Lavender Bathroom), 2004
Flex print
30 x 38 inches
Photo courtesy Sperone Westwater, New York

carroll dunham laurie simmons

CARROLL DUNHAM IS first and foremost a painter. Since the early 1980s, when he initially became inspired to paint on supports of wood veneer, the artist has been developing a highly personal iconography of orifices and appendages rendered in a lyrically exuberant pictorial language that is at once figurative and abstract. His large-scale paintings of the last decade or so have been accurately characterized as "cartoon-like," and surreal male creatures with penises for noses and flubbery females with bulbous lips and protuberant breasts continue to haunt his vividly imaginative pictorial universe. About five years ago, Dunham began focusing his attention on a solitary phallus-nosed, top-hatted male protagonist, locating him ultimately in a series of austere black-and-white painterly landscapes grouped together under the rubric "Mesokingdom." Lurking somewhere in the recesses of his mind, no doubt, were the curvaceous receptacles the artist identifies as female—figures who were poised to return with a vengeance in an unexpectedly explosive guise.

Dunham has commented that he finds painting to be a "limiting condition within which absolutely anything goes." "I like painting because it's so limited," he notes, "it's so uptight, so old and so flat and so rectilinear."[1] Although Dunham has always considered the restrictive confines of the stretched canvas oddly invigorating, this perception on his part may help explain the artist's recent foray into the expansive realm of sculpture. *Female Portrait (Second Generation, B)* is one of several metal silhouettes that grew out of the artist's experimentation with a laser cutter to transfer images to woodblocks in 2002.[2] After working with foam-core maquettes, Dunham went on to produce three different series of freestanding "steel ladies," who, as Johanna Burton so astutely put it, "have the distinct appeal of Alexander Calder/Aubrey Beardsley hybrids."[3] The titles of the series—*Frozen Shadows*, *Female Portraits*, and *Captured Shadows*—tersely convey the shadowy nature of these wildly demonstrative, black-as-night

viragoes who, ironically, are less volumetric than their painted counterparts. They perch on actual benches—part void and part solid—the negative space within and around them exuberantly and brilliantly activated.

Dunham's work was included in both the 1985 and 1995 Whitney Biennials, and in 2002, a twenty-year retrospective of his work was staged at the New Museum of Contemporary Art in New York. His paintings can be found in the permanent collections of numerous museums, including the Museum of Modern Art, Whitney Museum of American Art, Walker Art Center, and Museum of Contemporary Art, Chicago.

JR

1 "Carroll Dunham Interviewed by Matthew Ritchie," in *Carroll Dunham: Paintings* (New York: New Museum of Contemporary Art, 2002), 107.
2 See Molly Nesbit, "A Note on the Process," in *Carroll Dunham: He, She, and It* (New York: Gladstone Gallery, 2004), n.p.
3 Johanna Burton, "On the Brink," in *Carroll Dunham* (London: White Cube, 2003), n.p.

Female Portrait (Second Generation, B), 2003
Painted aluminum and wood
65 x 78 x 25 inches
Photo courtesy Gladstone Gallery, New York
Copyright Carroll Dunham 2003

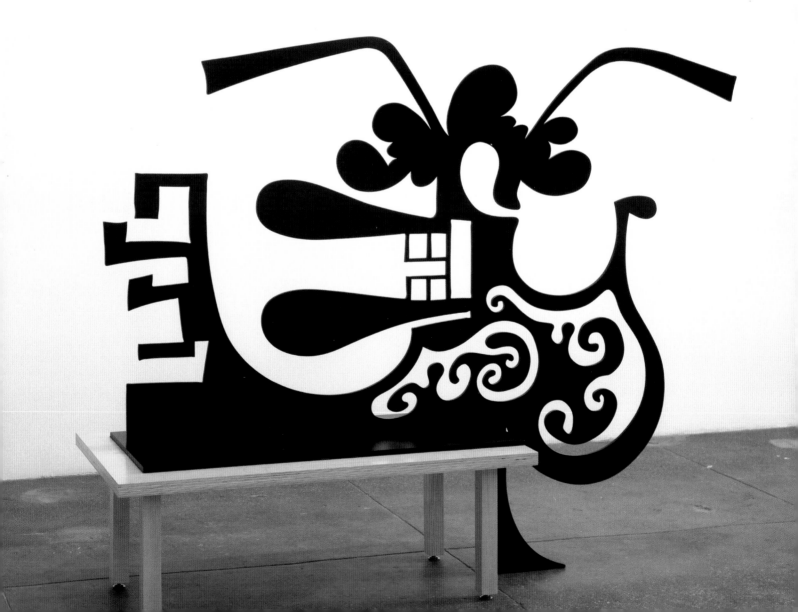

JULIE BURLEIGH CATHERINE OPIE

PAINTER JULIE BURLEIGH acknowledges that she looks to the styles of the past to create a dialogue that engages contemporary concerns. Inspired by the Spanish Baroque painter Francisco de Zurbarán, particularly his haunting images of monks at prayer, and the painterly brushwork and "classic" portraiture of Dutch artist Franz Hals, Burleigh has created a series titled *Brothers and Sisters*, drawing on the traditions of both Baroque masters to explore issues of identity and community.[1]

Painterly and evocative, *Brother #5* captures the "pensive" state of mind that Burleigh finds so compelling in the work of Zurbarán, an artist who so singularly captured the ecstasy and spirit of a profoundly devout faith.[2] Her sitters are placed against mostly monochromatic backdrops, their features suggested through a patchwork of tonal variations reminiscent of Paul Cézanne's masterful constructive strokes of color. Burleigh reduces her figures to their most elemental characteristics, stripping them of the particulars of age, race, creed, or sexual orientation, evidence perhaps of the influence of the eighteenth-century anatomical illustrations the artist includes in her repository of sources. The title of the series suggests familial bonds, yet Burleigh maintains that she employs the terminology more in the sense of "religious and spiritual orders, as well as the brothers and sisters of the gay community." Throughout all the portraits, Burleigh employs a color palette that relates to a group of landscape paintings that preceded the series. "The landscapes and the portraits," she notes, "try to lead the viewer to a place of both recognition and rediscovery. The colors in the portraits in particular allude to a non-human spectrum of color, i.e., color as another being or beast might perceive it, while at the same time, they express empathy."

Burleigh was born in Louisiana and received a B.F.A. from the School of the Art Institute of Chicago, and an M.F.A. from the Tyler School of Art in Philadelphia. She has participated in exhibitions across the country and has received residencies and awards from Yaddo, the Ragdale Foundation, and Department of Cultural Affairs in Chicago. Burleigh, who lives and works in Los Angeles, has taught at Washington University in St. Louis and at the University of California, Los Angeles.

BK/JR

1 All quotes from the artist are derived from e-mail correspondence dated September 5, 2005, and February 28, 2006.
2 Jonathan Brown, *Francisco de Zurbarán* (New York: Harry N. Abrams, 1974), 13.

Brother #5, 2004
Oil on linen
44 x 36 inches
Photo courtesy the artist

CaTHerine opie julie Burleigh

CATHERINE OPIE VIVIDLY RECALLS the photograph that changed the course of her life: an image of a young girl dwarfed by the mechanism of a Carolina cotton mill by Lewis Hine. Only 9 years old when she first encountered the image while working on a school report, Opie was instantly drawn to the truth of that black-and-white photo, and she decided—practically on the spot—that she wanted to take photographs for a living.[1] Opie went on to establish herself as a social documentary photographer of her own generation, gaining notoriety in the early 1990s through a series of studio portraits of her friends within the queer leather population of Los Angeles. Opie has since produced a diverse body of work that has been praised for its formal elegance as well as its visual clarity and honesty. Working in series, she has turned her camera on the strip malls, freeways, and surfers in her southern California landscape in an effort to, as she puts it, "catalogue and archive the people and the places around me."[2] Opie claims that her "obsession" with documentary photography comes from a "deep-seated sense of the loss of time, and of how things shift so quickly."[3] This is evident throughout Opie's oeuvre and is perhaps best seen in the artist's latest body of work, *Children*, in which she returns to formal studio portraiture in an effort to capture that fleeting moment we identify as childhood.

Opie's return to the portrait studio, inspired by her long-hoped-for attainment of "a partner, a child, and a car seat," was also partially due to her feeling that her new role in the world as a mother (and future PTA mom) was an appropriate time to begin photographing children.[4] Set against vividly colored backdrops, these children of the twenty-first century—Pilar, Skylar, Kayla, Harper, Noqusi—are gorgeous, strong, fragile, shy, naive, knowing … toddlers as well as teens … all of them the offspring of friends of the artist.[5] Dressed in a sequined top and a frilly pink headband, the young girl named Beatrice evokes images of a fairytale princess, yet her sullen demeanor and the seeming hint of eye makeup and lipstick situate her at the brink of adolescence, where dress-up and role-playing will no longer suffice as forms of entertainment. The psychological charge of this tenuous maturity resonates throughout the visually stunning *Children* series, encouraging the viewer to ponder youthful innocence in a society in which children all too quickly become adults.

Originally from Sandusky, Ohio, Opie moved to California as a young teen and received her M.F.A. from the California Institute of the Arts in 1988. Her work has been shown extensively throughout the United States, Europe, and Asia; most recently she was included in the 2004 Whitney Biennial and that same year received the Larry Aldrich Award from the Aldrich Contemporary Art Museum. Major solo exhibitions of her work have been seen at the Walker Art Center; Museum of Contemporary Art, Chicago; Photographers' Gallery, London; and Museum of Contemporary Art, Los Angeles. Opie resides in Los Angeles and is a professor at the University of California, Los Angeles.

BK/JR

1 As quoted in Maura Reilly, "The Drive to Describe: An Interview with Catherine Opie," *Art Journal* 60 (Summer 2001): 87.
2 As quoted in Reilly, 87.
3 As quoted in Russell Ferguson, "'How I Think': An Interview with Catherine Opie, Part Two: May 2000," in *Catherine Opie* (London: The Photographers' Gallery, 2000), 50.
4 Tyler Green, "Artist, Leather Dyke, PTA Mom," *BlackBook* 32 (Spring 2005), text available at http://www.blackbookmag.com/Spotlight_On/2005/Issue_41/index.aqf.
5 E-mail to authors, January 13, 2006.

Beatrice, 2004
C-print
20 x 16 inches
Photo courtesy Regen Projects, Los Angeles

SYLVIA PLIMACK MANGOLD Robert Mangold

SYLVIA PLIMACK MANGOLD made her reputation as an artist in the late 1960s and early '70s as a painter of interiors—wood floorboards, studio walls, banisters, mute corners of rooms—producing work that was both minutely descriptive and inherently abstract. Writing about her work in 1968, art historian Linda Nochlin noted the frequent "substitution of the part for the whole, [the] zoom in for a close-up of an even more restricted fragment," suggesting the artist's preference even then for random cropping and close vantage points.[1] These same formal strategies are evident in the body of work that has occupied Plimack Mangold for the last two decades: portraits of individual trees found on the Hudson River Valley farm she and her husband call home.

The maples, oaks, and elms in Mangold's latest watercolors and oils fill the picture plane, their branches amply extending from one edge of the canvas to the other. In the winter paintings, her trees are skeletal networks, viewed as though seen from the ground and creating a delicate but dramatic relief against the pale sky. The lush summer images, like *The Pin Oak July August*, display the same intricate networks interspersed and overlaid with translucent washes of color that evoke the shimmering leaves and glowing canopy of the majestic tree. Plimack Mangold initially rendered the trees on her property at a distance, adopting a more traditional landscape stance and grounding the spectator firmly at the periphery. Gradually, however, she moved in, eliminating the foregrounds and forcing the spectator to penetrate the shelter of the foliage. Referring to one of her images of a favorite elm, she once noted, "I try to have this tree form exist on canvas in the way that I experience it as I work I want this painting to do what the tree does: to enclose you but still let you feel the outdoors—open and airy."[2]

Plimack Mangold was born in New York City and attended the Cooper Union, after which she earned a B.F.A. at Yale University. Her work has been seen in solo exhibitions at the Herbert F. Johnson Museum of Art at Cornell University, University of Michigan Museum of Art, Minneapolis Institute of Arts, and Neuberger Museum of Art, and in 1994, a major retrospective of her paintings was organized by the Albright-Knox Art Gallery and traveled to the Wadsworth Atheneum and the Museum of Fine Arts, Boston. Plimack Mangold's work resides in the permanent collections of many major museums, among them the Whitney Museum of American Art, Brooklyn Museum, Museum of Modern Art, Detroit Institute of Arts, Walker Art Center, Dallas Museum of Art, and the Museum of Fine Arts, Boston.

CS/JR

1 Linda Nochlin, *Realism Now* (Poughkeepsie. N.Y.: Vassar College Art Gallery, 1968), 11; as quoted in Ellen G. D'Oench and Hilarie Faberman, *Sylvia Plimack Mangold: Works on Paper 1968–1991* (Middletown, Conn.: Davison Art Center, Wesleyan University, and the University of Michigan Museum of Art, 1992), 19.
2 As quoted in D'Oench, "A Universe of Trees: Prints by Sylvia Plimack Mangold," in *Sylvia Plimack Mangold: Works on Paper 1968–1991*, 78.

The Pin Oak July August, 2004
Watercolor and pencil on paper
22 x 30 inches
Photo courtesy Alexander and Bonin, New York

ROBERT MANGOLD SYLVIA PLIMACK MANGOLD

CRITICS WRITING ABOUT the column paintings of
Robert Mangold have drawn comparisons with a
host of vertical structures—everything from Trajan's
Column and Gianlorenzo Bernini's serpentine
supports to Constantin Brancusi's sleek forms and
urban skyscrapers, even the Twin Towers.[1] Yet as
Francine Prose has noted, Mangold's columns
aren't Bernini's or Trajan's, but "are wittier and
more subtle, more interested in asking questions
and eliciting conversation than in making brash
statements, less attuned to the trumpets and cym-
bals than to the resonance of strings."[2] Indeed
architectural and sculptural associations with the
column form fade away as the viewer ponders the
familiar motif in Mangold's flattened, reductive
compositions. Monochromatic and often brilliantly
colored, these soaring totems enframe a delicate
fugue of undulating graphite lines set against the
ghosted armature of an often barely discernible
grid. For Arthur Danto, the "metaphor of dance is
irresistible," for these sinuous glyphs reveal, as he
suggests, an unexpected "grace of weaving and
unweaving we would not have anticipated."[3]

Mangold typically begins such work by simply
drawing a line on a blank gessoed canvas or sheet of
paper. Thin layers of color are then applied, and the
intersecting "waveforms" are redrawn as needed.[4]
In preliminary pieces such as this untitled study
from 2003, pastel rather than acrylic paint serves as
an overlay—or what Mangold terms the "surface
container"—on a smaller, yet still majestic scale.[5]
Although the impact of the orange-red overlay is
immediate, the line breaks through and is reiterat-
ed atop the pastel, inviting the gaze of the viewer
upward and underscoring the essential verticality of
the column form. Often the lines are paired in the
column paintings; here, the duo becomes a trio as a
doubled line adds its movement to the limned
dance. As in the acrylic paintings in the series,
Mangold's linear "scaffold," to borrow from Danto
once again, is faintly visible in this pastel study,
providing a gentle matrix for the graphing of these
mellifluous curves.

Recent highlights in Mangold's long and distin-
guished career include solo exhibitions at the
Museum Weisbaden in Germany, where he was
awarded the Alexej von Jawlensky-Preis der Stadt
Wiesbaden award, and at the Hallen für neue Kunst
in Schaffhausen, Switzerland. In 2004, a group of
Mangold's column paintings was included in the
Whitney Biennial, marking his fourth appearance at
that important venue. Mangold's work is represent-
ed in most major collections around the world, and
the second volume of the catalogue raisonné of his
work was published in 1998.

CS/JR

1 See, for instance, Francine Prose, "Notes from the Border:
Robert Mangold's Column Paintings," in *Robert Mangold:
Column Paintings* (New York: Pace Wildenstein, 2004), and
Arthur C. Danto, "Robert Mangold's *Column Paintings*," *Art on
Paper* 8 (May/June 2004): 60–63.
2 Prose, 8.
3 Danto, 63.
4 Danto, 61.
5 As quoted in *Inside the Studio: Two Decades of Talks with Artists in
New York*, ed. Judith Olch Richards (New York: Independent
Curators International, 2004), 253.

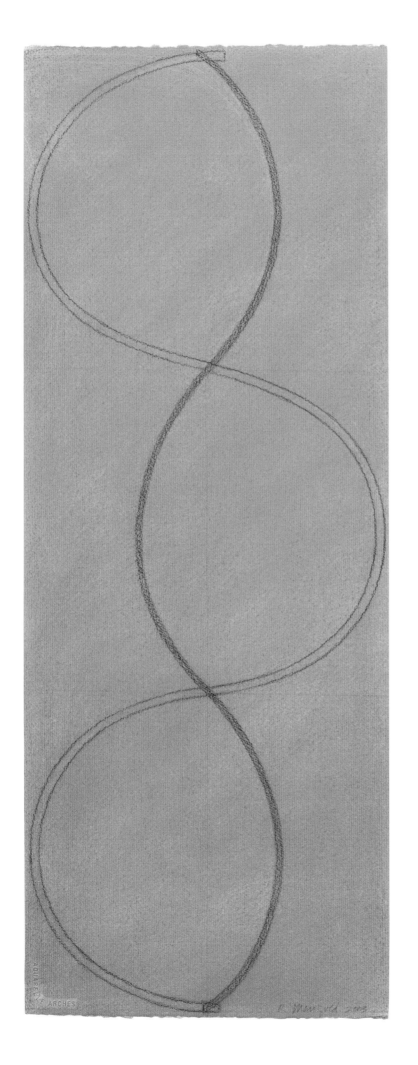

Untitled, 2003
Pastel, graphite, and black pencil on paper
30 ¼ x 11 ¾ inches
Photo courtesy Pace Wildenstein, New York

wendy edwards jerry mischak

WENDY EDWARDS TERMS the lacy nets that stretch across her canvases "reticulations." Using thick paint squeezed from a pastry bag, Edwards applies these reticulations in an almost calligraphic gesture, writing across the surface, intersecting the lines to form loose grids.¹ Alternately containing and revealing, protecting and confining, the undulating webs float above broadly applied fields of color, creating a three-dimensional effect that draws viewers into the melee even as they are kept at a distance by the intervening latticework. The green fishnet that adorns the surface of *Lilly*, however, is nearly translucent, mitigating the distance between the viewer and the pink magma below. In musing about the origin of these reticulations, Edwards points to similar models in nature and the built world, observing cycles of repetition and pattern in decorative architectural elements, ceramic tiles, textiles, and leaves.²

Edwards, a professor of painting at Brown University, lives and works in Providence, Rhode Island. Her most recent one-person exhibitions include *New Paintings* at OH+T Gallery in Boston, *The Skin Between* at Wheaton College, and *Grandes Peintures sur Papier* at the Centre International d'Art Contemporain in Pont Aven, France. Edwards is the recipient of fellowships from the MacDowell Colony, Tabor Academy in Marion, Massachusetts, and International School of Theory in the Humanities at Santiago de Compostela, Spain. She has served as artist-in-residence at the Hambridge Center in Rabun Gap, Georgia; Pouch Cove Foundation in Newfoundland, Canada; and in Auvillar, France. Her work resides in the permanent collections of such institutions as the Rhode Island School of Design Museum, San Antonio Museum of Art, University of New Mexico, and United States Information Agency.

CS

1 "New Paintings: Wendy Edwards," at http://www.ohtgallery.com.
2 "Reticulations," unpublished artist statement, 2002.

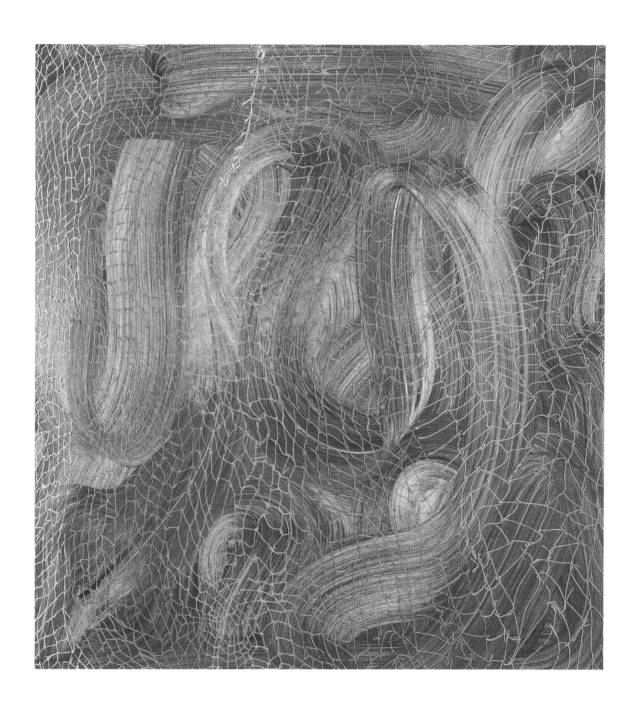

Lilly, 2004
Oil on canvas
44 x 42 inches
Photo courtesy OH+T Gallery, Boston

Jerry MISCHAK

AT FIRST GLANCE, *Spill* might seem to be a radical departure in the oeuvre of sculptor Jerry Mischak. Mischak is best known for sculptures that feature tightly wrapped, almost skin-like duct tape stretched over objects that he has found or built. In such works the tape obscures the object beneath, yet also reveals contours that might otherwise go unnoticed.[1] *Spill* is part of a new body of work that explores the sculptural possibilities of tape itself, a material that until recently in the artist's mind was subordinate to the found or fabricated object it wrapped. In creating this piece, Mischak experiments with the encasing quality of tape and tape-like materials, exploiting their capacity to arrest movement. By using a new plastic casting material, which acts much like paint, Mischak has found that he can freeze the string—stop the spill, as it were—and preserve it indefinitely.[2]

Jerry Mischak earned a B.F.A. at the Rhode Island School of Design and an M.F.A. at the University of Wisconsin, Madison. He lives and works in Providence, Rhode Island, and teaches painting at RISD and Brown University. Recent exhibitions of Mischak's work include *Color Coded*, a solo effort at the Islip Art Museum in Islip, New York, and several group shows, among them *Humanoid*, at the Frederieke Taylor Gallery, and *Mindscapes*, at the Pavel Zoubok Gallery, both in New York. He has produced window installations for Bloomingdales, Elizabeth Arden, and Barneys on Madison Avenue in New York, and is currently creating a large piece of public sculpture for the city of Pasadena, California.

CS

1 See Linda J. P. Mahdesian, "Art that sticks with you: Jerry Mischak's on a roll with works in duct tape," at http://www.octanecreative.com/ducttape/art/mischak.html.
2 Phone conversation with the artist, September 2005.

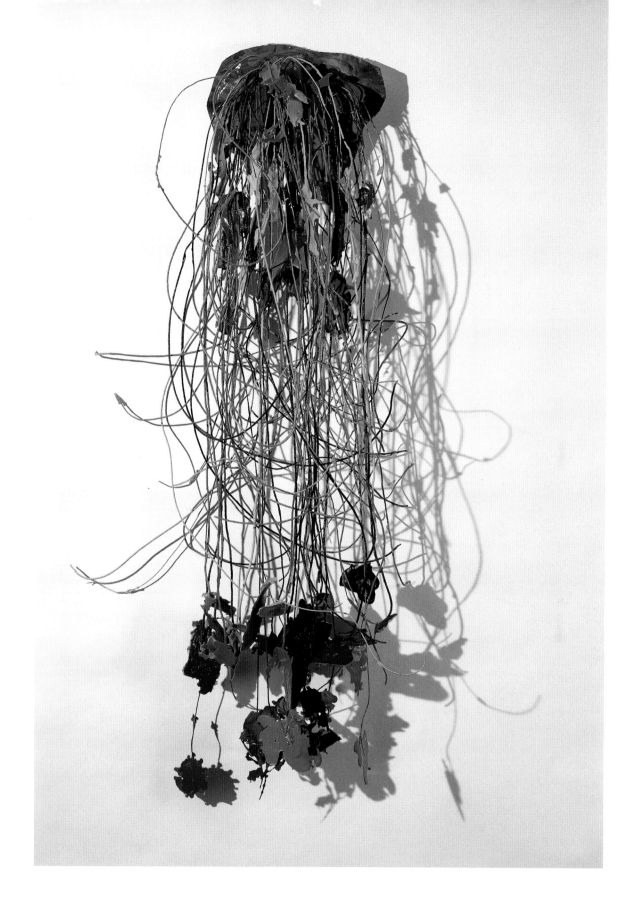

Spill, 2002
Plastic, string, and soil
56 x 18 x 8 inches
Photo courtesy the artist

BETTY WOODMAN

BETTY WOODMAN HAS BEEN a volcanic force in international ceramics for nearly a half century, a fact amply demonstrated by the institutional recognition afforded her work in the major retrospective organized by The Metropolitan Museum of Art in 2006. Particularly known for her dazzling, oversized "pillow pitchers" and elaborate soup tureens, Woodman in recent years has further expanded the idiom of wheel-thrown clay production to include complex installations in which ceramics are integrated with painting as sculptural pictorial elements. Although Woodman has always considered herself a folk potter who makes art that functions, her mural-scaled "ceramic pictures" chart new high-art territory, blithely eliding the distinction between craft and fine art that has long plagued the reception of contemporary ceramics.

Woodman divides her time between studios in New York and Italy, and her work engages in a raucous and animated dialogue with artistic traditions across the globe. Communicating a hedonistic embrace of life, her ceramic vessels and wall reliefs find their inspiration in a wide range of cultural sources: Greek and Etruscan pots, Roman wall painting and floor mosaics, Baroque chamber music, Italian opera, mannerist garden statuary, Tang Dynasty glazed ceramics, and the painted interiors and cutouts of Henri Matisse, among them.[1] The robust scale and substantial weight of her clay works are unusual in traditional ceramics. Seemingly intended for mythical giants of the forest, her wares are almost too large for mere mortals to use, yet too seductive and exquisite not to try.

Ceramic Pictures of Korean Paintings: Cactus, Lotus, and Butterfly is one of a series of recent ceramic floral works inspired by a trip to Korea in 2001, and formally it echoes the symmetry, simplified forms, high-keyed coloration, and floral exuberance of Korean *morando*, or folk paintings of peony blossoms. Lotus flowers, emblems of summer and spiritual purity, are also favored by Korean folk painters, and in this ceramic picture, their pink, anemone-like striations flutter alongside

colorful butterflies, buoyant ciphers of joy and conjugal love in Korean symbology.[2] Always evolving from the spiraling life of being thrown on the potter's wheel, Woodman's elastic forms adorn the wall in an explosion of scorching color and sensuous gesture, intentionally defying containment and categorization. Operating within the interstices of painting and sculpture, Woodman dares to scale a boundary, an abyss, by defying limitations of hallowed traditions. Proceeding with consummate confidence, seasoned familiarity, and the knowledge of infinite possibilities, she emerges from the uncertain fires of the kiln with a luminescent palette and soaring ceramic forms that belie their earthy origins.

Woodman has received fellowships from the National Endowment for the Arts and Rockefeller Foundation, and in 1998, she was awarded the "Visionary Award" from the American Craft Museum in New York. She has had numerous one-person exhibitions, including *Betty Woodman: Ceramic Floral Works*, presented at the Montclair Art Museum in 2002, and her work is featured in many public collections, among them the Whitney Museum of American Art, Museum of Modern Art, Metropolitan Museum of Art, Los Angeles County Museum of Art, Philadelphia Museum of Art, Museum of Fine Arts, Boston, Detroit Art Institute, Museum of Decorative Arts of Montreal, Victoria and Albert Museum, and Musée des Arts Décoratifs, Paris.

MA/JR

1 Arthur Danto identifies "communicative vitality" as Woodman's signature as an artist in his recent essay, "Communicating Vases: The Centrality of the Vessel in Betty Woodman's Art," in Janet Koplos, Arthur C. Danto, and Barry Schwabsky, *Betty Woodman* (New York: The Monacelli Press, 2006).
2 See Yeolsu Yoon, *Handbook of Korean Art: Folk Painting* (London: Laurence King Publishing, 2003).

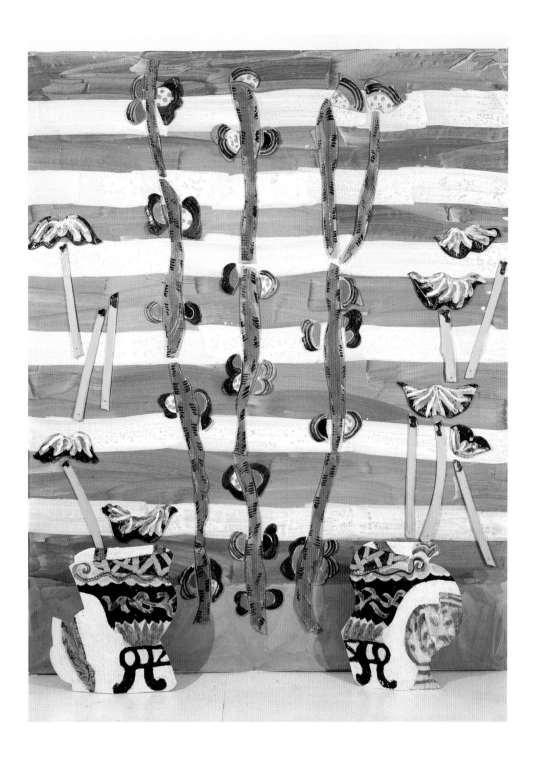

Ceramic Pictures of Korean Paintings: Cactus, Lotus, and Butterfly, 2005

Glazed earthenware, epoxy resin, lacquer, paint, and canvas

120 x 90 x 12 inches

Photo courtesy the artist and Max Protetch Gallery, New York

George woodman Betty woodman

ALTHOUGH STRIKINGLY MODERN in appearance, George Woodman's richly layered photographs dialogue with a distant classical past and, lately, with the very origins of the medium itself. The recent photo-murals follow and, in many ways, extend the conceptual underpinnings and technical discoveries of an exquisitely beautiful group of photomontages titled *Museum Pieces*, a lush body of work begun in the late 1980s, when the artist began focusing almost exclusively on photography after many years of working as a painter. In these black-and-white silver prints, which Woodman produced in studios in New York, Italy, and Boulder, Colorado, time seems suspended in a dream, and transparent, overlapping realities from disparate worlds are simultaneously seen one through another. Emotional, psychological, and art historical associations add to the complexity as the intimate, sometimes claustrophobic space of the quotidian collides, layer upon layer, with the artist's own photographs of eroticized marble figures appropriated from classicism's voluptuous progeny. As Woodman has noted, "two levels of fiction emerge" in the museum pieces. "My pleasure in combining several representations within a single photographic image," he states, "is to place question marks around the ultimate subject, fictionalize it, and in the process draw our attention back to how it has been represented."[1]

Saskia with the Dragonfly is one of a group of recent photographs fabricated by Woodman with the aid of a camera obscura, an age-old device for arresting nature's fugitive reflections, which well pre-dates the earliest experiments in photography undertaken by the likes of Talbot, Niepce, and Daguerre in the early decades of the nineteenth century. Woodman intentionally courts creative technical processes where chance, serendipity, and the relinquishing of control in large part determine the finished work. Physically creating a still life composed of photographs and other objects, Woodman captures its image on a large sheet of photographic paper placed within a darkened chamber (pierced by a small hole with a lens) in the studio. After exposing the paper for as much as ten minutes and having worked without the aid of a viewfinder, Woodman chemically coaxes the indeterminate image to life in the camera obscura, experimenting with both positive and negative apparitions of his elusive (and purposefully allusive) still-life elements.[2] Echoing the content of the first daguerreotype ever produced—a faint, yet luminous *nature morte* featuring objets d'art in a corner of the French photographer's atelier—these studio still lifes resonate with personal meaning, as though we were privy to the fragile mysteries and intimacies of some private cabinet of curiosities. The photograph of the statuesque Saskia, friend of the artist, favored model, and granddaughter of painter Arshile Gorky as well as the English poet Stephen Spender, anchors the cryptic pictorial narrative, a beacon of beauty, clarity, and visual detail amidst the ghosted forms of her surroundings. "Of great concern to me," Woodman has written, "is the way in which the viewer sees through the layers of 'subject' in my photograph. I hope it is some pleasant archeology of styles, traces of narrative, sentiment, and not without some purely visual interest and beauty."[3]

Woodman currently divides his time between New York and Italy. His work can be found in numerous private and public collections, including the Museum of Modern Art, Solomon Guggenheim Museum, Whitney Museum of American Art, Brooklyn Museum, Houston Museum of Fine Arts, and Denver Art Museum. In 1998, the Palazzo Pitti in Florence, Italy, mounted a major exhibition of Woodman's photographs.

MA/JR

1 George Woodman, "Notes on Sculpture and Photography," in *Museum Pieces: Photographs by George Woodman*, essay by Max Kozloff (New York: Lo Specchio d'Arte, 1996), 77.
2 Woodman's process is discussed in depth in an exhibition brochure written by Nancy Princenthal and accompanying the exhibition *George Woodman: Camera Obscura Photographs* at Grand Arts, Kansas City, in 2004.
3 Woodman, 77.

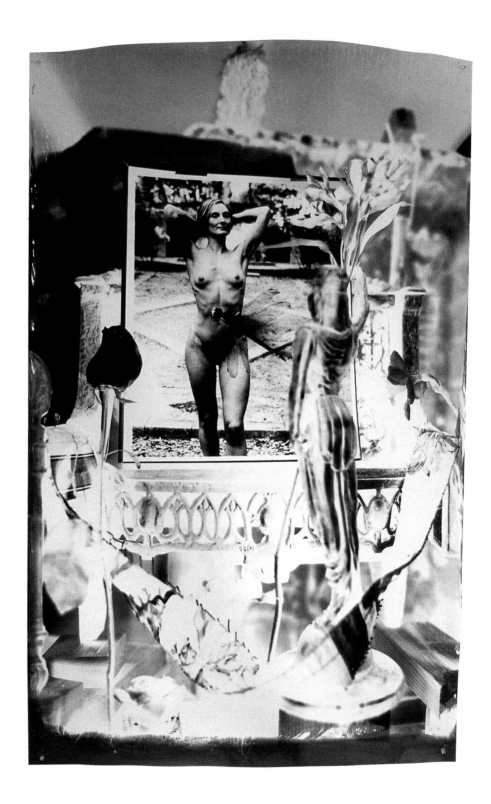

Saskia with the Dragonfly, 2004
Black-and-white silver print
70 x 42 inches
Photo courtesy the artist

Anne Harris PAUL D'AMATO

ANNE HARRIS' PORTRAITS are intense and disquiet-ing, capturing less a physical image than a psycho-logical state. Her figures are invariably fragile, vulnerably raw creatures, rendered with an almost cruel precision that allows the viewer a voyeuristic glimpse into private, painful insecurity. Much of Harris' oeuvre is composed of self-portraits, unset-tling depictions of emotionally and physically transformative states like pregnancy and aging. In her more recent work, the figures are adolescents, yet they are plagued with the same translucent, blue-veined skin and red-rimmed eyes, telling details that emphasize their delicate, damaged quality. In *Portrait (Beaded Dress)*, a young girl who resembles the artist is enshrouded by an ill-fitting garment, burdened by shoulder pads that accentu-ate her defeated posture. As Alison Ferris has noted, her "virginal attire is like the wrappings of mummies; it preserves [her] ... in a perpetual and uncomfortable adolescence."[1] Harris' compulsive attention to detail and her meticulously worked surfaces have sparked references to Albrecht Dürer and Jan van Eyck. Her work has also been discussed in conjunction with French artist Théodore Géricault, whose portraits of the insane attempted to visually categorize aspects of delusion. The com-parison seems apt, for as Ann Wilson Lloyd has observed, Harris' works are "creepily beautiful, otherworldly, yet frighteningly familiar."[2]

A native of Cleveland, Ohio, Harris received a B.F.A. from Washington University in St. Louis, Missouri, and an M.F.A. from Yale University. Her most recent exhibitions include several solo shows at the Nielsen Gallery, Boston, and DC Moore Gallery, New York, as well as *Without Likeness: Paintings by Anne Harris* at the Bowdoin College Museum of Art in 2003. Harris has participated in many group shows, among them numerous Portland Museum of Art Biennials; *The Figure: Another Side of Modernism* at the Newhouse Center for Contemporary Art in Staten Island; *Front Line: Ten Contemporary Draughtsmen in New England* at the Boston Athenaeum; and *The Nude in Contemporary Art* at the Aldrich Contemporary Art Museum in Ridgefield, Connecticut. Her many awards include a Guggenheim Fellowship, National Endowment for the Arts Fellowship, and Artist-in-Residency Grant in Roswell, New Mexico. Harris' paintings reside in the permanent collections of the Boston Public Library, DeCordova Museum and Sculpture Park, Fogg Art Museum, New York Public Library, and Yale University Art Gallery.

cs

1 Alison Ferris, "Without Likeness: Paintings by Anne Harris," in *Without Likeness: Paintings by Anne Harris* (Brunswick, Maine: Bowdoin College Museum of Art, 2003), 12.
2 Ann Wilson Lloyd, "Anne Harris at Nielsen," in *Art in America* 86 (April 1998): 125.

Portrait (Beaded Dress), 1999–2000
Oil on canvas
36 x 30 inches
Photo courtesy DC Moore Gallery, New York

PAUL D'AMATO Anne Harris

SINCE 1985, PAUL D'AMATO has spent every summer in Chicago, photographing the Mexican communities of Pilsen and Little Village at the outset and, more recently, the residents of the now-abandoned Henry Horner apartment complex, familiarly known as Cabrini Green. Driving into Pilsen on a whim, D'Amato initially sought to capture socially significant images, but soon became frustrated with the cold, documentary style of journalistic photography. He gradually moved beyond scenes that an outsider might witness on the street to more intimate vignettes of everyday life in the community. "I wanted drama and theater in my pictures and not superficial observations about Mexican culture, immigration or gang life," he remembers.[1] Ironically, it was through friendships with several members of the La Raza street gang that D'Amato gained entrance and acceptance into this insular community, as well as a different artistic perspective: "I hoped ... to photograph from the inside looking out instead of from the outside looking in."

Ultimately evolving from guest to resident of the dynamic community, D'Amato used his hard-won access to create intimate portraits of people he has come to know, not as members of a particular ethnic group, but as neighbors. He has brought this same sensibility to the images captured on Chicago's West Side, in the vicinity of Cabrini Green. The somber expression of the young homeless woman captured in *April* conflicts with her seemingly festive attire as she poses under a crumbling railroad bridge, incongruous against a background dramatically split between dark recesses and blinding sunlight. Incorporating traditional elements of portraiture—the front-and-center pose, the seated, three-quarter length stance—with a markedly untraditional location and unexpected subject, D'Amato confers a sense of monumentality and dignity onto an individual to whom society has ascribed little value historically and, tragically, even less interest.

A Guggenheim Fellowship in 1994 enabled D'Amato to spend a year in Pilsen, focusing his photography on an area of one square mile. Other awards include fellowships from the New England Foundation for the Arts and the Pollock-Krasner Foundation and an Illinois Arts Council Grant; D'Amato was also a fellow at the Rockefeller Study Center in Bellagio, Italy, in 1998. His work resides in the permanent collections of several museums, including the Metropolitan Museum of Art, Museum of Modern Art, Fogg Art Museum at Harvard University, Art Institute of Chicago, and Museum of Contemporary Photography in Chicago. Paul D'Amato received a B.A. from Reed College and an M.F.A. from the Yale University School of Art. He resides in the Chicago area and is currently an associate professor of photography at Columbia College.

CS

1 The artist's comments are borrowed from journal entries found at http://www.pauldamato.com and in the recently published collection of his photographs, *Barrio: Photographs of Chicago's Pilsen and Little Village*, foreword by Stuart Dybek (Chicago: University of Chicago Press, 2006).

April, 2004
C-print
35 ¾ x 28 ½ inches
Photo courtesy Howard Yezerski Gallery, Boston

DeBORaH WILLIS

Uncoupling
BY DEBORAH WILLIS

The photograph has long been used as an instrument of memory. As a mother, photographer, educator, curator, and soon-to-be ex-wife, I have used photography to tell stories about family life. This installation is a homage to my grandmother's stories. What I am interested in sharing is the notion of "turning corners" once a dream relationship has ended. When my former partner and I were asked to participate in this exhibition, I was thrilled to do so because we shared so many stories that fulfilled our dreams and imaginations as an artist-couple. We had planned to include work about our experiences in South Carolina. We often encouraged each other's art-making process. However, the day that we were photographed for this project, I did not know that my beloved husband was planning to leave me. I hugged and smiled as we posed for the photographer and responded to her questions about how we met and about our feelings and whether it was "love at first sight." So this project has been transformed into an installation about uncoupling and thoughts about the mother wit and wisdom I heard as a child. My former partner declined to participate in the show.

My experience with photography has had many dimensions. I attempt to relive family memories by incorporating old photographs and words from the "collective archive" of black culture into contemporary images exploring the nuances of memory. Studying photographs has inspired me to create work that is interpretative and experiential. My art has always focused on photography as biography, as a way of documenting the female story. I grew up in beauty shops; my mother had a shop in our family house in North Philadelphia, and I'd often listened to women talk about their relationships. This series is about my own experience with loss and how I am attempting to make sense and find humor as I reconsider my future.

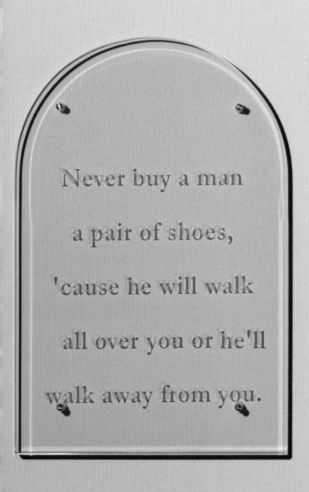

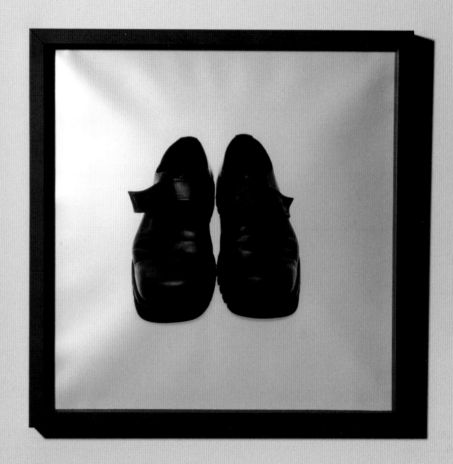

Mother Wit, 2004 (detail)
Installation with photographs and etched glass
Dimensions variable
Photo courtesy the artist

ROY DOWELL Lari Pittman

THE LEGACY OF MODERNIST COLLAGE is a rich one and is indebted to the pioneering examples of Pablo Picasso and Georges Braque, who nearly a century ago began applying newspaper and other unorthodox materials to traditional supports. Like the Cubists before him, Dowell has found that there is much to love in the ephemeral detritus and visual culture of his own time. In the early 1970s, while a student at the California Institute of the Arts, he kept a small notebook of collages and realized that this might be the direction his work should head when a friend showed an interest in them. A self-avowed heir to modernist formalism, Dowell has been "painting in a state of collage"[1] for well over two decades, producing, in the words of one critic, "a cut-and-paste version of Pop Art."[2]

Dowell acknowledges that his approach is essentially democratic, likening his process to his adopted, multicultural home of Los Angeles, which, he claims, "takes disparate sources and says, 'this can exist together.'"[3] Many of the artist's vibrant, large-scale canvases indeed literally incorporate disparate materials—snippets of signs, posters, advertisements, fabric—and call as well on a rich range of artistic influences, from Japanese art and Mexican billboards to the clangorous compositions of Stuart Davis and James Rosenquist. The painting-collages are generally untitled and numbered (a sure indication of his formalist bent) and typically pulsate with a kind of Dionysian exuberance and complexity. For this artist who claims that he has difficulty producing work "without at least twelve components," Untitled (#894) is unexpectedly restrained, elegant—even Apollonian—in its minimalism.[4] The fan or shell-like shape, partially enframed by cobalt blue, is borrowed from a hat in a Japanese print, yet Dowell notes that the particular source is not critical to the work's meaning. "As is the case with most of my work," he notes, "the sources are derived from a diverse collection of cultural references chosen primarily for their formal qualities and secondarily for what they may 'mean' or invoke."[5] Dowell's use of burlap, a nod to modernism's radical democratization of materials, adds a textural element and a coarse counterbalance to the fugue of circles floating weightlessly across the mottled white surface of the canvas. In this beautifully understated piece, Dowell moves away from the visual chaos of his declamatory "Pop" mode in search of the subtle, laconic poetry of the ordinary.

Dowell lives and works in Los Angeles, where he chairs the graduate studies department at the Otis College of Art and Design. He received both a B.F.A. and M.F.A. from CalArts and has exhibited his work in numerous one- and two-person exhibitions. His work can be found in the permanent collections of the Los Angeles County Museum of Art, Museum of Contemporary Art, Los Angeles, Hammer Museum, Portland Art Museum, and Phoenix Art Museum.

BK/JR

1 See Christopher Miles, "Roy Dowell: Painting in a State of Collage," in *Roy Dowell: A Survey Exhibition 1981–2005* (Los Angeles: Margo Leavin Gallery, 2006).
2 Holland Cotter, "Roy Dowell," *The New York Times*, February 26, 1999, B37.
3 As quoted in Kristine McKenna, "Roy Dowell's Mixed Bag of Tricks," *Los Angeles Times*, October 19, 1997, 61–62.
4 As quoted in McKenna.
5 E-mail to authors, April 19, 2006.

Untitled (#894), 2003
Acrylic and burlap on canvas
52 x 40 inches
Photo courtesy Margo Leavin Gallery, Los Angeles

Lari Pittman ROY DOWELL

ALTHOUGH HE CHARACTERIZES himself as a decorative painter, Lari Pittman does not believe that such a designation negates the emotional, intellectual, or philosophical impact of his work.[1] In 1985, Pittman was repeatedly shot in the stomach during an attempted home burglary, and the near-death experience, he has claimed, deepened his "sense of chaos in the universe."[2] Since that time, Pittman has openly infused his large-scale paintings with difficult, indeed chaotic content, exploring the dichotomy of good and evil from the vantage point of one who understands the fragility of life amidst death's spectre. Some twenty years later, Pittman continues to explore issues of duality through his vibrant, often elaborately ornamental paintings, purposefully blurring the distinction between reality and fiction.

Pittman's untitled painting in *Couples Discourse* continues in this vein by situating seemingly disparate objects—an oversized, turbine-like ceiling light, window blinds, a sailing vessel, a shark suspended from a disoriented fire hydrant—in an otherworldly, watery landscape that appears inexplicably to be indoors. Rays from an anthropomorphic sun and directional arrows inspired by advertising or road signage call our attention to these objects and in the process emphasize their essential disconnect. The massive shark in the foreground, part cartoon, part robot, may be emblematic of the sense of fear and apprehension that all human beings contend with on a daily basis, its menacing presence almost comical in this colorful landscape in which fear and humor are surrealistically intertwined. This intrinsic dualism, the artist contends, is ultimately related to his own sense of hybridity as a Latino American born to a Colombian mother and an Anglo-Saxon father, as well as to a profoundly personal understanding of simultaneous as opposed to sequential time.[3] For Pittman, the coalescence of a barrage of iconographic elements in one pictorial space—he calls it "layering"—is crucial to the experience of his work. "When you look at the paintings, it's not confusion that you're looking at, but a simultaneity of events in time It's not about confusion. It's about being able to circumnavigate through the painting, where there is something horrific and really silly, disturbing, and very buoyant."[4]

Pittman received his B.F.A. and M.F.A. from the California Institute of the Arts in the mid-1970s and since then has established himself as a major force on the international art scene. His work has been included in four Whitney Biennials as well as Documenta X, and in 1996, he was the subject of a major retrospective organized by the Los Angeles County Museum of Art. He has received numerous awards, including three National Endowment for the Arts fellowships and a Getty Fellowship for the Visual Arts, and his work is represented in private and public collections around the world. Pittman lives and works in Los Angeles and is a professor of painting and drawing at the University of California, Los Angeles.

BK/JR

1 Howard N. Fox, "Joyful Noise: The Art of Lari Pittman," in *Lari Pittman* (Los Angeles: Los Angeles County Museum of Art, 1996), 11.
2 As quoted in Linda Yablonksy, "From Picket Signs to Creeping Vines," *ARTnews* 104 (Summer 2005): 176.
3 Noticing his grandmother's concomitant feelings of joy and sadness during a family event, Pittman came to realize that the idea of the "bittersweet" is at the core of the notion of simultaneous time, a mode of perceiving he attributes to his South American Catholic roots. See Paul Schimmel, "An Interview with Lari Pittman," in *Lari Pittman*, 70–71.
4 As quoted in Schimmel, 71.

Untitled #2, 2003
Matte oil, aerosol lacquer, and cel-vinyl
on canvas over wood panel
76 x 102 inches
Photo courtesy Regen Projects, Los Angeles

GLADYS NILSSON JIM NUTT

ALTHOUGH HISTORICALLY WATERCOLOR has been seen as a bit of a dabbler's pursuit, particularly when practiced by "ladies," the fluid medium has held its own alongside oil painting for nearly a century and a half. For Gladys Nilsson, the luminous possibilities of watercolor have long appealed, as have the social pastimes of somewhat matronly "ladies." Ever since her youthful days as a founding member of the Hairy Who (a group of mild-mannered renegades who exhibited together in Chicago in the late 1960s), Nilsson has playfully, yet pointedly examined the foibles and follies of humankind via the larger-than-life female protagonists who populate her world of whimsy.

Nilsson's ebullient biddies have inspired florid commentary and hyperbolic literary references: Her "Lady Gullivers" typically tower above her "Lilliputian" male characters, who function as "mere accoutrements," one critic has noted, "in this realm of the feminine."[1] The setting of *Small Party* is unexpectedly sparse for this artist who, more often than not, fills her compositions with a dizzying array of pictorial incidents. Nilsson deftly conjoins a domestic interior space—the proper setting for one's tea party—and the exterior domain of nature, both of which are gendered spaces, archetypal ambits of the female, gargantuan or not. Nilsson notes that she enjoys the spaciousness of this piece and that her fancy is tickled by the pose, palette, and paint texture of that "twosome in gray" in the immediate foreground.[2] Perhaps the most germane reading of the artist's work remains that of Whitney Halstead, Nilsson's teacher, colleague, and friend, who got it exactly right in 1966, the year Nilsson first began exhibiting with the Hairy Who. Extolling her extraordinary "mastery of means," Halstead identified Nilsson's sense of the bizarre as "natural and unaffected," discovering in her work "unbelievable juxtapositions and incongruities which can be found threaded through our ordinary experience."[3]

Nilsson, who graduated from the School of the Art Institute of Chicago in 1962, resides in the Chicago area and is an adjunct professor of painting and drawing at her alma mater. Since her Hairy Who days, she has appeared in numerous solo exhibitions and group shows across the country and has remained an important voice within the group of figurative artists known as the Chicago Imagists. Her work is featured in the permanent collections of numerous public institutions, including the Art Institute of Chicago, Museum of Modern Art, Whitney Museum of American Art, Los Angeles County Museum of Art, Milwaukee Art Museum, Philadelphia Museum of Art, and Art Gallery of Western Australia in Perth.

JR

1 John Hallmark Neff, commentary in *Gladys Nilsson* (Chicago: Jean Albano Gallery, 2005); Lisa Stein, "Nilsson's Colors Continue to Get More Intense," *Chicago Tribune*, October 15, 1998; and Jim Yood, "Gladys Nilsson," *New Art Examiner* 22 (February 1995): 40–41.
2 E-mail to author, June 6, 2006.
3 Whitney Halstead, "There was a young lady who…," unpublished article printed in *Gladys Nilsson* (Davis, Calif.: John Natsoulas Press, 1993), 9–10. See James Yood's essay on the artist in this same publication for an excellent discussion of her work.

Small Party, 2002
Watercolor and gouache on paper
15 x 22 5/16 inches
Photo courtesy the artist and Jean Albano Gallery, Chicago

JIM NUTT GLADYS NILSSON

IN CHARACTERIZING THE WORK of the disparate group of artists who have come to be known as the Chicago Imagists—Jim Nutt, Gladys Nilsson, Ed Paschke, Roger Brown, among them—critics and historians have called on a colorful and expressive vocabulary. Labeled brash, dynamic, irreverent, pungent, crude, shocking, and even sadistic, the artwork produced by this important and idiosyncratic regional school found its inspiration in such diverse sources as popular culture (including comic books), American folk painting, and non-Western art and a guiding precedent in the illogical, meticulous fictions of the European Surrealists. Nutt gained national and international attention in the early 1970s through his participation in the 1972 Venice Biennale and, just two years later, via a touring retrospective of his work organized by Chicago's Museum of Contemporary Art, which included the Walker Art Center and the Whitney Museum of American Art on its schedule. Favoring imagery in which cartoon-like characters cavort in carefully drawn proscenium stage sets, Nutt was subsequently cast as the provincial bad boy, creating a ruckus with his imagined theatre of the absurd on the outer fringes of the contemporary art world.[1]

Some thirty years later, Nutt's work inspires a new lexicon—elegant, graceful, dare one say, decorous—although the quirky idiosyncrasies of his early oeuvre remain. In 1987, Nutt began a series of portraits of imaginary women and since that time has produced a modest number of meticulously delineated, labor-intensive acrylic paintings both on panel and canvas, as well as a larger body of related graphite drawings. Women have always been featured, even favored players in Nutt's imagistic world; in the recent work they reign supreme, regal in their bearing, idées fixes without any thematic or narrative glue linking them. "I'm really trying to make an image that I like," Nutt confesses, "or something that intrigues me or interests me without over-thinking it."[2] The painted portraits have been compared to everything from Byzantine mosaics and early Renaissance panels to Netherlandish painting and American folk art. The drawings of these fictional females—part court jester, part school marm—resemble an oddly successful admixture of Pablo Picasso and J.-A.-D. Ingres, a conjoining of the modern and the classical whereby anatomical distortion is tempered by the graceful lyricism of a deftly drawn line. Ultimately exploratory studies for the more time-consuming paintings, the highly finished drawings, Nutt claims, "really are about trying to get things straight in my head. Trying to get it organized. The focus is not on the drawing, it's on getting something done."[3]

Nutt studied at the School of the Art Institute of Chicago from 1960 to 1965 and, except for a brief stint in Sacramento (1968–76), has resided in the Chicago area since that time. Along with his wife, Gladys Nilsson, Nutt was a member of the Hairy Who group, which exhibited together in the Windy City in the late 1960s. In addition to the museums mentioned above, Nutt has shown his work at the Milwaukee Art Museum, Museum of Modern Art, Neuberger Museum of Art, National Gallery of Art, Cleveland Museum of Art, Nelson-Atkins Museum of Art, Virginia Museum of Fine Arts, Stedelijk Museum in Amsterdam, and other prominent public collections.

JR

1 For a comprehensive survey of Nutt's work into the early 1990s, see *Jim Nutt* (Milwaukee: Milwaukee Art Museum, 1994) with essays by Russell Bowman, Lynda Roscoe Hartigan, and Robert Storr.
2 As quoted in "Carroll Dunham in conversation with Jim Nutt," in *Jim Nutt: Drawings and Paintings* (New York: Nolan/Eckman Gallery, 2003), 6.
3 As quoted in Dunham interview, 8–9. For an interesting discussion of the role of drawing in Nutt's work, see Dennis Adrian, "The Metaphysics of Perception in the Drawings of Jim Nutt," *Drawing* 15 (July–August 1993): 25–29.

Untitled, 2005
Graphite on watercolor paper
15 x 14 inches
Photo courtesy the artist and Nolan/Eckman
Gallery, New York

JUDITH RaPHaeL TONY PHILLIPS

RECENTLY THE TERM APPROPRIATION has been bandied about with great frequency in critical discussions of contemporary art, particularly figurative art. Borrowing from the hallowed past, of course, has long been a mainstay of the academic tradition, built as it is on the terra firma of a revered and emulated canon of artists and styles. Painter Judith Raphael came of age in the wake of feminism and, like many artists of her generation, questioned the seeming paucity of strong female heroines—both as makers and as subjects—in the history of art. Best known for her provocative portraits of girls on the brink of adolescence, Raphael began appropriating heroic male postures from the Western tradition in part to empower her young protagonists and to redress that troublesome lack. Often situated in sparse, non-descript settings, these girls occupy a liminal space between childhood and pubescence, robbed of contextual clues other than clothing, hairstyles, and occasional accoutrements. "For me," Raphael has noted, "the subject of girlhood visually reconfigured takes place over time, not in a specific time or context."[1]

In *Pandora/Caught Red-Handed*, Raphael calls on the ancient Roman sculpture of the Primaporta Augustus—an iconic emblem of male political power and might—in the hesitant, if histrionic, stance of her young heroine. Echoing the emperor's graceful contrapposto pose, with her left rather than right arm raised, this sullen Pandora wears a sundress rather than a military cuirass as she unleashes a world of woes from her mythical box. Pandora, the first woman on earth according to Greek mythology, takes the fall, much like Eve, her intrepid Judeo-Christian counterpart, for the evils befalling humankind. Raphael's original musings on Pandora, she observes, were "speculations on how from Eve to Pandora to the complaint of the abusive husband . . . women are blamed for bringing all their troubles on themselves."[2] Raphael is quick to remind us that not all is lost, however, for Hope lay at the bottom of Pandora's box of malevolence. The artist gives form

to that ray of hope in the luminous birds floating through the upper portion of the painting. These faint creatures disconcertingly mingle with and even morph into streamlined shapes resembling airplane bombers—subconscious memories unearthed, apparently, by Raphael, the daughter of a World War II veteran. Yet, the news is not all bad, for as Carol Becker has written, "Pandora's box, once opened and unhinged, allows nightmares to be revealed while also liberating heretofore unimagined play, freedom of movement, and possibilities of thought."[3]

Raphael received her M.A. from Northwestern University and has shown her work in solo and group exhibitions at the National Academy of Design, Fort Wayne Art Museum, Chicago Cultural Center, Union League Club of Chicago, Springfield Art Museum, DeCordova Museum and Sculpture Park, Tarble Arts Center at Eastern Illinois University, Rockford Art Museum, and Museum of Contemporary Art, Chicago. In 2004, she was the recipient of the Adolph and Clara Obrig Prize from the National Academy.

SH/JR

1 This quote and some of the information presented here can be found in Staci Boris, "What Are You Looking At?" in *My Little Pretty: Images of Girls by Contemporary Women Artists* (Chicago: Museum of Contemporary Art, 1997), 16–17.
2 E-mail to authors, January 13, 2006.
3 Carol Becker, "Reconfiguring the Heroic," in *Reconfiguring the Heroic* (Chicago: Artemisia Gallery, 2000), n.p.

Pandora / Caught Red-Handed, 2003
Acryla on panel
42 x 28 inches
Photo courtesy the artist and gescheidle, Chicago

TONY PHILLIPS JUDITH RAPHAEL

THE ADJECTIVES USED to characterize Tony Phillips' work collectively paint a picture of a rather peculiar sensibility: Gently surreal, idiosyncratic, phantasmagorical, obsessively tuned, and visionary are but a few of the terms that have been employed to describe the artist's jewel-like, yet oddly disturbing, pastels. As fellow painter Robert Berlind has suggested, Phillips' most compelling pictures betray a "particular tension between humor and eeriness, between the familiar and the eccentric, between the fanciful and the obsessive."[1] Lauded for the dazzling precision and remarkable clarity of his magic realist technique, Phillips explores and gives visible form to the menacing anxieties that haunt our collective psyches.[2]

Much of Phillips' recent work turns that exploration inward and focuses on that most haunting of all anxieties—the fear of aging and death—which plagues us all. In *I Am the Bomb*, Phillips exposes this most basic fear through the expanding, balding, and androgynous body of a grossly exaggerated alter-ego, set within an eerily deserted landscape lit only by the accusing rays of an approaching police car, a crescent moon, and myriad pinpricks of light in the night sky. Less a self-portrait than a fearful projection of an imaginary (potential) persona, this unnerving vision is, according to the artist, "a dreadful meditation, a fantasy about the vicissitudes of aging, about the fears and horrors concerning the spreading waistline, loss of hair, of manliness, of sanity, the loss of dignity and self-control."[3] The work's somewhat unexpected, multivalent title came to Phillips gradually as the piece evolved, a memory of a student's terse, yet quintessentially hip, words of praise directed toward him, the mentor and elder: "You are the bomb!" Obviously a linguistic signifier of Phillips' apparent "coolness," the phrase playfully evokes the impressive spread of the artist's senescent body, but hints at something more sinister. "I had to think about the ironic, event the most horrific implications of being considered the bomb," Phillips notes, "the terrorist, the madman. I had to envision what ghost lay in the back of my mind"

Phillips received his B.F.A. and M.F.A. degrees from Yale University in the early 1960s. He taught at the School of Visual Arts in New York and the University of Pennsylvania before accepting a faculty position in 1969 at the School of the Art Institute of Chicago, where he chaired the department of painting and drawing from 1998 to 2001 and recently retired as professor emeritus. He has received awards from the National Endowment for the Arts and Illinois Arts Council and had resident fellowships at the MacDowell Colony, Yaddo, Virginia Center for the Creative Arts, and Djerassi Foundation. Phillips' work has been seen in numerous group and solo exhibitions.

SH/JR

1 Robert Berlind, "Tony Phillips at Marianne Deson," *Art in America* 74 (July 1986): 126.
2 See Alan G. Artner's reviews of the artist's work in the *Chicago Tribune*, April 2, 1993, sect. 7, 48, and January 24, 2003, sect. 7, 21.
3 E-mail to authors, May 21, 2006.

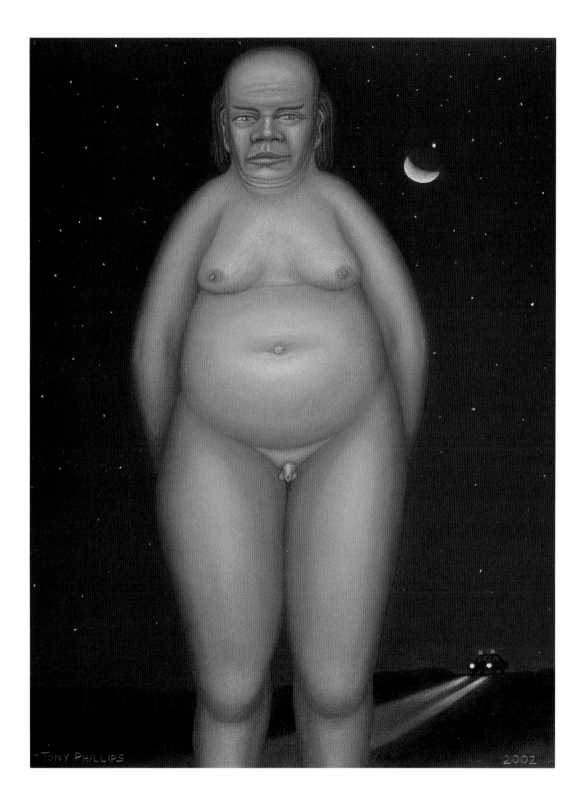

I Am the Bomb, 2003
Pastel on paper
11 ½ x 8 ½ inches
Photo courtesy the artist and gescheidle, Chicago

Mary Lucier Robert Berlind

INTERNATIONALLY RECOGNIZED video artist Mary Lucier is best known for her multilayered, environmental video installations chronicling catastrophic ravages of nature and humanity embedded in the American landscape. A pioneer of video, she quickly moved from sculpture and performance art to slide projection and single-channel, black-and-white video in the early 1970s, focusing initially on process and exploring both the possibilities and limitations of the new technology. In the last two decades, her multi-channel video installations, now filmed in lush color, have become increasingly theatrical as she narrates the history, memory, courage, and spirit of her protagonists in the face of trauma and loss.[1] Whether set against the backdrop of Grand Forks, Charleston, Valdez, or her native Bucyrus, Ohio, Lucier's videos "speak to us about ourselves as social and individual beings," she maintains, "and about the way in which we are alienated from aspects of our environment."[2]

A sense of psychic alienation permeates Lucier's video portrait of John Lado Keni, a Sudanese refugee whom the artist met in Des Moines, Iowa, in 1999. An inveterate writer and note taker, Lucier documented her encounter with this engaging individual:

He has been deaf from birth. He is a storyteller. Speaking neither his native language nor English, he has developed an animated sign language all his own ... accompanied by emphatic vocal sounds. He performs the story of his escape from the Sudan in a monologue—turned dialogue with himself—of personalized gestures and sounds. His movements and utterances have been electronically processed to accentuate the staccato rhythms and urgency of his communication[3]

Lucier initially presented the video of Keni in the context of an installation titled *Migration* (2000), in which she juxtaposed his mural-scaled "talking" head with an image of a Monarch butterfly—another migratory traveler—projected onto a circular screen. In the two-channel installation, Keni's determined efforts to narrate his journey were all the more compelling alongside the carefree insouciance of the mute creature.[4] The immense scale of Keni's projected image and the shifting overlap of his animated face and gesticulating hands contribute to the dramatic import and impact of the portrait, even when shown independently. Impatient, at times anguished, Keni seems confident in his attempts to keep his story flowing, and we share his excitement even though his punctuated language confounds us. The transparencies and opacities of his multiplied image are captivating and give us a sense of many stories being told at once and over time as past becomes disconcertingly present. Despite the vulnerability of her subjects, Lucier accomplishes her powerful storytelling here and elsewhere with remarkable reserve and dignity, relinquishing the meaningless "spectacle" so characteristic of the information age in which we live, in favor of the mundane traumas and life experiences we share as human beings despite our differences.

Lucier has shown her work at major institutions across the country, including the Museum of Modern Art, Carnegie Museum of Art, Wadsworth Atheneum, Museum of Contemporary Art, Los Angeles, Dallas Museum of Art, Norton Gallery of Art, Whitney Museum of American Art, Walker Art Center, and San Francisco Museum of Modern Art, and her videos have been seen internationally in Paris, Lyons, Amsterdam, Madrid, Sydney, Vienna, Budapest, and Nagoya, Japan. Her work is represented in public collections in New Zealand, Canada, Amsterdam, Germany, and the United States. Hamilton College organized a mid-career retrospective of her work in 2002.

MA/JR

1 See Peter Doroshenko's interview with the artist first published in the *Journal of Contemporary Art* (1990) and reprinted in *Mary Lucier*, ed. Melinda Barlow (Baltimore: The Johns Hopkins University Press, 2000), 226–27.
2 Doroshenko interview, 228.
3 Artist's Notes (November 2000) in *Mary Lucier, New Video Installations: Forge, Migration, Nesting* (Hamilton, N.Y.: The Clifford Gallery, Colgate University, 2001), n.p.
4 See Charles Hagen's comments in "Mary Lucier: In the Light of Memory," in *Mary Lucier, New Video Installations*, and also Deirdre Boyle, "A Certain Kind of Grace: Rediscovering Mary Lucier's Video Art," in *Mary Lucier: Selected Works 1975–2000* (Clinton, N.Y.: Emerson Gallery, Hamilton College, 2002), 15–16.

Video still from *Portrait: John Lado Keni*, 2000

Video and audio installation. Color, sound. 15:00, continuous repeat

Dimensions variable

Photo courtesy the artist and Lennon, Weinberg, Inc.

ROBERT BERLINDMary Lucier

Jogging Madison Park
water meets asphalt.
Rose-grey, cool umbers, translucent greens
intercept parallel realities,
the rim of light and the heat of day.
Intimacies of waters unnerve curious readings
read much better upside down.

Remarkable this magical skin
revealing itself in a glimpse,
inventing elementary logics.

Scanning, searching, rippling in a pure flash,
recognizing waters to be a wave,
mind pictures see voices.

Criss-crossing, sliding, sudden silence,
slipping into sweeter juices
in between July pines and damaged wood.

—Micaela Amateau Amato, Bob Berlind,
Leon Golub, and Irving Sandler[1]

ALTHOUGH PAINTER ROBERT BERLIND is drawn to
the everyday—the quotidian, the familiar, the ver-
nacular—poetry, rather than prose, seems to best
describe his almost-hallucinatory glimpses of both
the urban and rural landscape. Berlind is fascinated
by the networks of patterns inherent in nature's
eternal flux: puddles inflected by gentle drops of
rain, trembling reflections and ripples on the sur-
face of a quiet stream, the dancing leaves of summer
pines or the whispers of windblown trees on a
moonlit night. We witness the miraculous simplicity
of flickering sunlight across grasses in a front yard
in the moist heat on a summer's day, or the thun-
derous tumult of water splashing over boulders in a
fast-moving river. Viewing Berlind's landscapes we
become acutely aware of our own fascination with
nature's poetic, ephemeral beauty, intuitively
transported to private places in our own memories
that make our intimate worlds suddenly seem vast,
monumental. "What I'm after," Berlind notes, "is
the moment of seeing that is always before under-
standing, when something enters your whole body,
before you sort it out."

Berlind captures that elusive moment in *Fence,
Trees, Raindrops* #2, collapsing spatial distinctions in
a haiku of reflections that takes us by surprise and
disturbs the "normal order of things," to borrow
from Irving Sandler. Indeed, nothing is as it seems
in this monochromatic slice of urban life where
water, sky, and asphalt merge and which we view
suspended precariously in a strangely disquieting
field. Berlind confesses that he was drawn to the
"ineluctable play of the visual" in that shallow puddle
on a city sidewalk and intrigued by its shimmering,
not-to-be-trusted simulacrum of the "real" world.
Tied to nature yet intrinsically abstract, these com-
plex and ambiguous reflections of light may indicate
a larger worldview of a reality poised somewhere on
the precipice between fact and fiction—between the
prose of everyday life and the poetry of an elusive
truth just beyond our knowing.

Berlind received both his B.F.A. and M.F.A.
from Yale University, and since 1979, he has been a
professor at Purchase College, State University of
New York. In addition to numerous gallery shows,
he has exhibited his work at the National Academy
of Design, Philbrook Museum of Art, John and
Mable Ringling Museum of Art, Maier Museum of
Art, Neuberger Museum of Art, and many university
galleries. Berlind has received awards and fellow-
ships from the National Endowment for the Arts,
American Academy and Institute of Arts and
Letters, and Pollock-Krasner Foundation, and his
work can be found in numerous public and corpo-
rate collections. Berlind is also a writer and a fre-
quent contributor to *Art in America*. In 2001, he was
elected to the National Academy of Design.

MA/JR

1 Robert Berlind, "Artist's Notes: Puddle;" Irving Sandler,
"Robert Berlind: Attending to the Eye and the Hand;" and Leon
Golub, untitled statement, in *Robert Berlind: Paintings 1982–1996*
(Dayton: University Art Galleries, Wright State University,
1997). Additional quotes from Sandler and the artist are taken
from this source. For an excellent discussion of Berlind's
work, including a slightly smaller version of *Fence, Trees,
Raindrops*, see Karen Wilkin, "Robert Berlind: Seeing Before
Understanding," in *Robert Berlind: Recent Works* (Tulsa:
Alexandre Hogue Gallery, University of Tulsa, 2005).

Fence, Trees, Raindrops #2, 2002
Oil on linen
48 x 96 inches
Photo courtesy Tibor de Nagy Gallery, New York

JOYCE KOZLOFF Max KOZLOFF

AS A PAINTER WHO FOUND HER VOICE as part of the Pattern and Decoration movement in the 1970s, Joyce Kozloff has long appropriated materials from a diverse range of cultures and artistic sources. Addicted to world travel, Kozloff acknowledges that she has "an insatiable visual appetite," and her work with maps and collage from the last decade amply confirms that.[1] Kozloff's recent series titled *Boys' Art*, a group of twenty-four collages based on old military maps and diagrams, furthers the artist's fascination with cartography and the "mapping" of power, concerns that resonate in a string of projects since the mid-1990s including *Imperial Cities* (1994); *Around the World on the 44th Parallel* (1994–1995); *Knowledge* (1998–2000); *Targets* (1999–2000); and *Dark and Light Continents* (2002). Kozloff began working intensively on the *Boys' Art* series in the days immediately following 9/11, safely ensconced in a studio along the Ligurian coast as part of a residency at the Bogliasco Foundation outside Genoa, Italy. In that quiet haven, with pencil in hand, Kozloff began replicating the maps, illustrations, and diagrams of historic military battles that she had carted with her from New York. The two-dozen grisaille drawings would ultimately provide both the decorative schema and conceptual framework for the exploration of a centuries-old theme—the penchant for warfare on the part of both men and boys.

Once back in New York, Kozloff was inspired by one boy's art—the childhood "superhero" drawings made by her son—to violate her meticulous hand-drawn maps with, as she puts it, "absurd and/or tragic incursions from high and popular culture."[2] Miniaturized color photocopies of Nikolas Kozloff's comic book warriors soon found their place in the limned stage sets alongside a host of duplicated warmongers, appropriated from such disparate sources as Leonardo, Francisco de Goya, self-taught recluse Henry Darger, nineteenth-century drawings of Plains Indian battles, and Japanese theatrical illustrations. In *Imola*, Lakota and Arapaho warriors share the military playing field (ostensibly the site

of a 1797 battle between Papal and French forces) with Japanese actors, a gun-wielding monkey from *Tintin au Congo*, and royal military engineers and "sappers" in a deliberate misalliance of time periods and geographical locales.[3] "I like to juxtapose things that are not humorous separately," Kozloff has noted, "but ludicrous when together."[4] The visual humor evident in *Boys' Art* is of course tempered by the historical and ongoing reality of global military conflict, what the artist might call "boys' play."

Kozloff's work is represented in many private and public collections, including the National Gallery of Art, Metropolitan Museum of Art, Museum of Modern Art, and National Museum of Women in the Arts. The artist has also completed numerous public commissions, notably ceramic and marble mosaics for the San Francisco International Airport (1983); Harvard Square Subway Station (1985); Washington National Airport (1997); and the Chubu Cultural Center in Kurayoshi, Japan (2001).

J R

1 As quoted in *Crossed Purposes: Joyce & Max Kozloff*, Interviews by Moira Roth (Youngstown: The Butler Institute of American Art, 1998), 8.
2 Joyce Kozloff, introduction, *Joyce Kozloff: Boys' Art*, essay by Robert Kushner (New York: D.A.P., 2003), 5.
3 A complete list of the sources used in Imola can be found in *Joyce Kozloff: Boys' Art*, 57.
4 As quoted in *Crossed Purposes*, 10.

Segment of Flow, 2004
Insulation board, Sheetrock, Masonite, vellum, and paint
120 x 74 inches
Photo courtesy Frederieke Taylor Gallery, New York

Byron Kim Lisa Sigal

"I THINK I'M A PAINTER WHO has recently ventured
out into other media," Byron Kim commented in
early 2006.[1] With that succinct statement, Kim set
forth his understanding of his "inner artist," while
also acknowledging the disparate, multimedia array
of work that has come out of his studio as of late.
Kim first burst onto the international art scene at
the 1993 Whitney Biennial, where he was repre-
sented by *Synecdoche*, a multi-panel, monochro-
matic (yet also multi-chromatic) musing on the
legacy of monumental abstraction, skin tones, and
personal/communal identity. Unlike the Minimalist
canvases of the 1960s that inspired him, Kim's
abstract paintings reverberate with personal mean-
ing and memory and become, as he says (borrowing
from British poet William Wordsworth), "spots of
time."[2] Horizontal stripes, variously hued, thus
might be inspired by the hard-to-forget, yet not-
precisely-remembered pink color of his childhood
home or the head-to-toe coloration of his brightly
garbed son, Emmett, or even the striped turtleneck
he wore for weeks in kindergarten after a teacher
complimented him in it. The personal, even the
mundane, merges with the abstract sublime in
Kim's "Sunday Paintings," diminutive glimpses of
clouds and sky captured routinely and methodically
on that day of rest over the course of several years
and accompanied by diary-like notations scrawled
across fields of monochromatic blue: "It was sunny
today so it didn't seem so freezing cold. I'm think-
ing about flying to San Diego to help mom out
w/grandpa. He's become very confused 1/21/04,
4 pm, Brooklyn."[3]

*What I See (Family, Torrey Pines State Park,
La Jolla)*, a digitally produced photo-montage on
a monumental scale, is indicative of one of many
new directions Kim is currently pursuing, yet it also
suggests that the artist's personal life and private
intimacies remain the guiding force behind his
work. The personal imprint is obvious: These are
Kim's wife, children, and parents, and those are
his feet and elongated shadow in the immediate
foreground. As the title reveals, Kim is clearly the

authorial voice—pater familias-photographer-artist,
but he's also the "dad-husband-son" dutifully
photographing his sightseeing family in a state
park near his parents' home. Is *What I See* a
Wordsworthian "spot of time" (an epiphanic child-
hood moment that the tired kids in this family
snapshot will fondly recall one day?) or is it merely
a fractured tourist postcard documenting yet
another "photo opportunity"? Kim positions
himself somewhere between these extremes,
reminding us that our fractured identities make us
who we are and confirming that such moments as
these—these moments of "ordinary intercourse,"
to borrow again from Wordsworth—provide their
own epiphanies.

Kim grew up in La Jolla, California, and
Wallingford, Connecticut, and earned a bachelor's
degree at Yale University, where he studied English.
After working as a studio assistant to Philip
Pearlstein for few months in 1983, Kim went on
to pursue further training at the Skowhegan School
of Painting and Sculpture. He has received awards
from the Joan Mitchell Foundation, National
Endowment for the Arts, New York Foundation
for the Arts, Louis Comfort Tiffany Foundation,
American Academy of Arts and Letters, and Korea
Arts Foundation of America, and his work has been
seen in many major museums around the world.
In 2004, the Berkeley Art Museum and Pacific
Film Archive presented a major retrospective of
Kim's paintings.

JR

1 "Rush Interactive," radio interview with Michael Rush for WPS1
 MOMA, edition 20, first broadcast January 9, 2006. Available at
 http://www.wps1.org/include/shows/rush_interactive.html.
2 For a thorough discussion of Kim's work, including his interest
 in Wordsworth, see Eugenie Tsai, "Between Heaven and Earth,"
 in *Threshold: Byron Kim, 1990–2004* (Berkeley: University of
 California, Berkeley Art Museum and Pacific Film Archive,
 2004), 15–24. "Spots of time" is from Wordsworth's autobio-
 graphical poem titled "The Prelude," the first version of which
 was penned in 1799.
3 See Tsai, 22–23.

What I See (Family, Torrey Pines State Park,
La Jolla), 2005
Digital C-print
61 3/8 x 107 5/8 inches
Photo courtesy the artist and Max Protetch
Gallery, New York

Nancy Spero

ALTHOUGH OBVIOUSLY AN independent, vocal, and vibrant artist in her own right, Nancy Spero has long been an integral player in the formidable art-world duo of Spero and Golub. Her soul mate and husband of fifty-three years, painter Leon Golub, passed away in August 2004, leaving behind a remarkable artistic legacy as well as a keenly felt void in both the public and private realms. Spero's 2005 show at Galerie Lelong featured a single work, *Cri du Coeur*, a monumental paper frieze featuring a procession of mourning female figures borrowed from an Egyptian tomb painting, which poignantly encircled the lower walls of the gallery. A "cry from the heart" might well characterize the entire oeuvre of this driven artist who found her mature voice amidst a chorus of fellow feminists and anti-war activists in the late 1960s. Spero, as critic Thomas McEvilley recently noted, is an artist "who has long empathized in her work with the sorrows of history," yet clearly her heartfelt cry in this case, he astutely observed, "refers to something much closer at hand."[1]

Since the 1970s, Spero has favored the paper scroll format, delighting in its multicultural resonances—Chinese paintings, Egyptian papyri, Japanese kakemonos—and its obvious nonconformity in an era in which the stand-alone canvas was the surest sign of modernist mastery and bravado. At times appropriating the gestural, painterly language of the male-dominated art world from which she emerged, Spero soon focused her attention exclusively on the female subject, and over the course of her long career, she has continued to produce iconoclastic compositions that "simultaneously deconstruct, transform and celebrate images of women from past cultures."[2] In the *La Folie* diptych, hand-printed and collaged female figures from a variety of sources invoke, yet also challenge, classical archetypes. Decorum gives way to ecstasy or perhaps madness (*folie*) as these disturbing heroines—both buoyant and bestial—carry on amidst a matrix of violet, black, and blood-red brushstrokes. At times bold, at times merely a shadow, these strangely familiar figures resist easy interpretation, although the title resonates with the age-old linkage of women and hysteria. Women's sexuality, as Spero has argued, has long been associated with the "unclean, frightful, [and] out of control," and historically "despised and feared"[3] Perhaps the "mad" maidens shimmering on the surface of *La Folie* are merely wearing their hearts on their sleeves, succumbing, as so many of us do, to the folly of love.

After study at the School of the Art Institute of Chicago and the Ecole des beaux-arts, Spero began exhibiting her work in the 1950s and was a founding member of A.I.R. Gallery, an alternative women's cooperative gallery in New York, in 1972. Spero has exhibited her work in solo and group exhibitions both nationally and internationally, including the recent retrospectives, *Nancy Spero: Weighing the Heart Against a Feather of Truth*, at the Centro Galego de Arte Contemporánea in Santiago de Compostela, Spain (2004–05), and *Nancy Spero: A Continuous Present* at the Kunsthalle zu Kiel (2002). Her work is included in numerous public collections around the world, among them the Museum of Modern Art, Brooklyn Museum of Art, Whitney Museum of American Art, Philadelphia Museum of Art, Uffizi Gallery, Tate Gallery, National Gallery of Canada, and National Gallery of Australia. In March 2006, Spero was elected to the American Academy of Arts and Letters.

CS/JR

1 Thomas McEvilley, "Spero's Cry," *Art in America* 94 (May 2006): 164.
2 Ingeborg Kähler, "A Continuous Present: On the Exhibition," in *Nancy Spero: A Continuous Present*, ed. Dirk Luckow and Ingeborg Kähler (Düsseldorf: Richter Verlag, 2002), 19.
3 As quoted in Anne Barclay Morgan, "From Victim to Power: Women Across Cultures and Time—An Interview with Nancy Spero," *Art Papers Magazine* 25 (November/December 2001): 34.

La Folie I and *II*, 2001
Handprinting and printed collage on paper
Diptych, each image 49 x 19 ½ inches
Photo courtesy Galerie Lelong, New York

Boys' Art #4: Imola, 2002
Collage and pencil
12 x 18 inches
Photo courtesy DC Moore Gallery, New York

Max KOZLOFFJOYCE KOZLOFF

"MODERN STREET PHOTOGRAPHERS," according to Max Kozloff, "are fluttering, intrusive, yet vaguely stealthy creatures who live on edge in quizzical search of imagery they cannot foresee."[1] Kozloff ought to know, for although he is better known as a critic and writer on photography, he has been practicing the art himself since the mid-1970s. According to Kozloff, he made the transition from "American tourist taking pictures" to serious photographer in 1975, all the while continuing to find his subject matter in jaunts around the world or around his own urban backyard.[2] His first important body of work focused on shop windows—in honor of French photographer Eugène Atget—but he soon found himself less intrigued by the theatrical display before him than by the intrusive reflections and shadows coming from the bustling activity on the avenue behind his tripod. Kozloff literally turned his back on those display windows and began photographing the life of the street, capturing its surfeit of visual detail and incongruous juxtapositions in dynamically unstable compositions. "To walk the streets is to be confronted with a stupid abundance of confused, jostled, and small incidents," Kozloff has written. "The photograph will fix any instance of it with a drastic particularity, wispy, random, and therefore perhaps trivial."[3]

Kozloff remains drawn to scenes of display and communal festivities, aspects that coalesce in *Macy's Christmastime*. Although the artist maintains that the visual stimulus overrides emotionally meaningful content, the emotional center of this vibrant streetscape is a quiet little boy with white earmuffs, who alone stares at the photographer and functions as an emblem of calm in a sea of disparate movement and shifting reflections. "Even when I'm immersed in large crowds," Kozloff notes, "the subject who draws me is one who seems alone"[4] Kozloff acknowledges that his documentary approach is out of sync with the purposeful artifice and theoretical underpinnings of much contemporary photography. Nonetheless, the artist's intuitive sense of color and penchant for evocative composi-

tions are resoundingly evident in an oeuvre that has remained conceptually focused on the visual wonders of the street over the course of several decades.

Kozloff holds a master's degree in art history from the University of Chicago. After writing for *The Nation* (1961–68), he served as associate, contributing, and executive editor of *Artforum* from 1963 to 1976. He is the author of numerous books, and his published volumes of collected writings on photography include *Photography and Fascination* (1979), *The Privileged Eye* (1987), and *Lone Visions/Crowded Frames* (1994). Kozloff first began showing his work in 1977, and since that time has continued to exhibit his work in both solo and group exhibitions around the world.

J R

1 Max Kozloff, "A Way of Seeing and the Act of Touching: Helen Levitt's Photographs of the Forties," in *The Privileged Eye: Essays on Photography* (Albuquerque: University of New Mexico Press, 1987), 29.
2 As quoted in *Crossed Purposes: Joyce & Max Kozloff*, Interviews by Moira Roth (Youngstown: The Butler Institute of American Art, 1998), 38. Much of the information presented here is taken from this interview with the artist.
3 Kozloff, 29.
4 As quoted in *Crossed Purposes*, 40.

Macy's Christmastime, 1991
C-print
14 ½ x 18 inches
Photo courtesy the artist

LISA SIGAL BYRON KIM

LISA SIGAL IS A PAINTER who lately has consistently been thinking outside of the frame. Although Sigal worked with traditional materials for many years, a trip to the coast of Ireland several summers ago led her to search in her work for a sense of openness beyond the limiting confines of the stretched canvas. "Part of my motivation for abandoning the traditional frame of painting [came] from a kind of claustrophobia," she has noted, "a discomfort with human containment." Casting aside, as she terms it, the "52-inch center" model for hanging paintings, Sigal began painting directly on the wall and from there began "dismantling" the partitions that typically define our living space in a series of site-specific and often-monumental installations. "I began to question the material substance of walls," Sigal has written. "Their physical fact often contradicts the shifting nature of our desires."[1]

In 2004, Sigal produced a group of painting installations made up of portable panels of Sheetrock, wood, cardboard, insulation board, and Masonite, as well as collaged elements, for a show at the Frederieke Taylor Gallery titled (in lowercase) "house paint." Splayed across the walls and even protruding into the space of the gallery, the painted panels featured glimpses of buildings that together formed disjunct, yet surprisingly fluid, urban landscapes. In *Segment of Flow*, an installation from this body of work, snippets of architecture from an industrial zone at the city's edge cascade downward, the site's dreary palette enlivened by strips of bright blue and a burst of yellow vellum. "The imagery, like the process," Sigal points out, "is a collage of sorts," referencing both the old and the new in the cityscape and mitigating, perhaps, the urbanite's sense of anxiety in the midst of confined spaces.[2] No longer merely a blank slate, the wall supporting this expansive industrial landscape is implicated in the pictorial space, functioning more as vista than mere barrier.

Sigal received her M.F.A. from Yale University in 1989. Her work has been supported by the New York Foundation for the Arts, Ballinglen Arts Foundation, Joan Mitchell Foundation, and Elizabeth Foundation for the Arts. Her installations have been shown recently at the Brooklyn Museum of Art, Queens Museum of Art, and Aldrich Contemporary Art Museum, as well as White Columns and the Sculpture Center in New York.

JR

1 Letter to Frederieke Taylor, spring 2004. The text of the letter is available at http://www.frederieketaylorgallery.com/2004 Nov.html.
2 E-mail to author, March 9, 2006.

Checklist of the Exhibition

1 **Suzanne Anker**
American, b. 1946
*Rorschach Series: Bear, Crab, and
Wolf*, 2004–05
Rapid Prototype Sculpture (plaster
and resin)
Dimensions variable
Courtesy the artist

2 **Frank Gillette**
American, b. 1941
The Broken Code (for Luria), 2003
Digital print mounted on alu-
minum
24 x 72 inches
Courtesy the artist

3 **Eleanor Antin**
American, b. 1935
Going Home, from *Roman Allegories*,
2004
Chromogenic print
48 1/2 x 102 3/4 inches
Courtesy Ronald Feldman Fine
Arts, New York

4 **David Antin**
American, b. 1932
How Wide is the Frame?
Audio recording of improvised per-
formance at the Getty Research
Institute, Los Angeles, April 26,
2002 (33:17)
Courtesy the artist and
PENNSound, University of
Pennsylvania

5 **Arlene Burke-Morgan**
American, b. 1950
Painting #2, 2003
Acrylic on woven and stitched
paper
29 1/2 x 29 1/2 inches
Courtesy the artist

6 **Clarence Morgan**
American, b. 1950
Autocratic Personality, 2004
Graphite, acrylic, and ink on paper
20 1/8 x 14 3/16 inches
Courtesy Gallery Joe, Philadelphia

7 **Clarence Morgan**
American, b. 1950
Cartesian Framework, 2004
Graphite, acrylic, and ink on paper
20 1/8 x 14 3/16 inches
Courtesy Gallery Joe, Philadelphia

8 **Julie Burleigh**
American, b. 1961
Brother #5, 2004
Oil on linen
44 x 36 inches
Courtesy the artist

9 **Catherine Opie**
American, b. 1961
Beatrice, 2004
C-print
20 x 16 inches
Courtesy Regen Projects, Los
Angeles

10 **Catherine Opie**
American, b. 1961
Sula, 2004
C-print
20 x 16 inches
Courtesy Regen Projects, Los
Angeles

11 **Patricia Cronin**
American, b. 1963
Memorial to a Marriage, modeled
2001–02, cast 2004
Bronze
17 x 27 x 53 inches
Courtesy the artist

12 **Deborah Kass**
American, b. 1952
Silver Deb, 2000
Silkscreen and acrylic on canvas
40 x 40 inches
Courtesy the artist

13 **Roy Dowell**
American, b. 1951
Untitled (#894), 2003
Acrylic and burlap on canvas
52 x 40 inches
Courtesy Margo Leavin Gallery,
Los Angeles

14 **Lari Pittman**
American, b. 1952
Untitled #2, 2003
Matte oil, aerosol lacquer, and cel-
vinyl on canvas over wood panel
76 x 102 inches
Courtesy Regen Projects,
Los Angeles

15 **Wendy Edwards**
American, b. 1950
Lilly, 2004
Oil on canvas
44 x 42 inches
Courtesy OH+T Gallery, Boston

16 **Jerry Mischak**
American, b. 1951
Spill, 2002
Plastic, string, and soil
56 x 18 x 8 inches
Courtesy the artist

17 **Anne Harris**
American, b. 1961
Portrait (Beaded Dress), 1999–2000
Oil on canvas
36 x 30 inches
Courtesy Alexandre Gallery,
New York

18 **Paul D'Amato**
American, b. 1956
April, 2004
C-print
35 3/4 x 28 1/2 inches
Courtesy Howard Yezerski Gallery,
Boston

19 **Nene Humphrey**
American, b. 1947
Pierced Red, 2003
Corsage pins, felt, and silk
9 x 8 x 9 inches
Collection of Barbara and Ira
Sahlman, New York

20 **Nene Humphrey**
American, b. 1947
Out of Bounds (Guizhou, China),
2003
Corsage pins, fabric, embroidery
thread, and map pin mounted on
board
48 x 48 x 2 inches
Courtesy the artist

21
Benny Andrews
American, b. 1930
New Home, from *The Migrant Series*,
2004
Oil and collage on canvas
66 x 90 inches
Courtesy ACA Galleries,
New York

22 **Joyce Kozloff**
American, b. 1942
Boys' Art #4: Imola, 2002
Collage and pencil
12 x 18 inches
Courtesy DC Moore Gallery,
New York

23 **Joyce Kozloff**
American, b. 1942
*Boys' Art #23: Iron Jar Fortress,
Korea*, 2002
Collage, colored pencil,
and pencil
12 x 18 inches
Courtesy DC Moore Gallery,
New York

24 **Max Kozloff**
American, b. 1933
Macy's Christmastime, 1991
C-print
14 1/2 x 18 inches
Courtesy the artist

25 **Max Kozloff**
American, b. 1933
*Post-Modern Burger Restaurant,
Miami Beach*, 1986
C-print
14 1/2 x 18 inches
Courtesy the artist

26 **Mary Lucier**
American, b. 1944
Portrait: John Lado Keni, 2000
Video and audio installation. Color,
sound. 15:00, continuous repeat
Dimensions variable
Courtesy the artist and Lennon,
Weinberg, Inc.

27 **Robert Berlind**
American, b. 1938
Fence, Trees, Raindrops #2, 2002
Oil on linen
48 x 96 inches
Courtesy the artist and Tibor de
Nagy Gallery, New York

28 **Helen Marden**
American, b. 1941
A Cascade for Gauguin, 2005–06
Acrylic and dry pigment on canvas
100 x 34 7/8 inches
Courtesy the artist

29 **Brice Marden**
American, b. 1938
Diagramed Couplet #1, 1988–89
Oil on linen
84 x 40 inches
Courtesy the artist

30 **Gladys Nilsson**
American, b. 1940
Small Party, 2002
Watercolor and gouache on paper
15 x 22 5/16 inches
Courtesy the artist and Jean Albano
Gallery, Chicago

31 **Gladys Nilsson**
American, b. 1940
A Little Re-Play, 2002
Watercolor and gouache on paper
22 1/2 x 15 1/4 inches
Courtesy the artist and Jean Albano
Gallery, Chicago

32 **Jim Nutt**
American, b. 1938
Untitled, 2004
Graphite on watercolor paper
16 x 15 inches
Courtesy the artist and
Nolan/Eckman Gallery, New York

33 **Jim Nutt**
American, b. 1938
Untitled, 2005
Graphite on watercolor paper
15 x 14 inches
Courtesy the artist and
Nolan/Eckman Gallery, New York

34 **Sylvia Plimack Mangold**
American, b. 1938
The Pin Oak July August, 2004
Watercolor and pencil on paper
22 x 30 inches
Courtesy Alexander and Bonin,
New York

35 **Robert Mangold**
American, b. 1937
Untitled, 2003
Pastel, graphite, and black
pencil on paper
30 1/4 x 11 3/4 inches
Courtesy Pace Wildenstein,
New York

36 **Judith Raphael**
American, b. 1938
Pandora/Caught Red-Handed,
2003
Acryla on panel
42 x 28 inches
Courtesy gescheidle, Chicago

37 **Tony Phillips**
American, b. 1937
A Short Life: Primed; Done,
2002
Pastel on paper
8 x 20 inches
Courtesy gescheidle, Chicago

38 **Tony Phillips**
American, b. 1937
I Am the Bomb, 2003
Pastel on paper
11 1/2 x 8 1/2 inches
Courtesy gescheidle, Chicago

39 **Lisa Sigal**
American, b. 1962
Segment of Flow, 2004
Insulation board, Sheetrock,
Masonite, vellum, and paint
120 x 74 inches
Courtesy the artist and
Frederieke Taylor Gallery, New York

40 **Byron Kim**
American, b. 1961
*What I See (Family, Torrey Pines State
Park, La Jolla)*, 2005
Digital C-print
61 3/8 x 107 5/8 inches
Courtesy the artist and Max Protech
Gallery, New York

41 **Laurie Simmons**
American, b. 1949
*The Instant Decorator (Lavender
Bathroom)*, 2004
Flex print
30 x 38 inches
Courtesy the artist and Sperone
Westwater, New York

42 **Carroll Dunham**
American, b. 1949
*Female Portrait
(Second Generation, B)*, 2003
Painted aluminum and wood
65 x 78 x 25 inches
Courtesy the artist and Gladstone
Gallery, New York

43 **Nancy Spero**
American, b. 1926
La Folie I and *II*, 2001
Handprinting and printed
collage on paper
Diptych, each image 49 x 19 1/2
inches
Courtesy the artist and Galerie
Lelong, New York

44 **Deborah Willis**
American, b. 1948
Mother Wit, 2004
Installation with photographs
and etched glass
Dimensions variable
Courtesy the artist and Bernice
Steinbaum Gallery, Miami

45 **Helen Miranda Wilson**
American, b. 1948
Blue Sky with Fifteen Clouds,
started November 1996
Oil on panel
9 15/16 x 10 inches
Courtesy DC Moore Gallery,
New York

46 **Timothy Woodman**
American, b. 1952
Ian Snowboarding, 2003
Aluminum and oil paint
24 1/2 x 14 3/4 x 5 inches
Collection of Ian Rosenberg,
New York

47 **Betty Woodman**
American, b. 1930
*Ceramic Pictures of Korean Paintings:
Cactus, Lotus, and Butterfly*, 2005
Glazed earthenware, epoxy resin,
lacquer, paint, and canvas
120 x 90 x 12 inches
Courtesy the artist and Max Protech
Gallery, New York

48 **George Woodman**
American, b. 1932
Saskia with the Dragonfly, 2004
Black-and-white silver print
70 x 42 inches
Courtesy the artist